The Alte Pinakothek   Munich

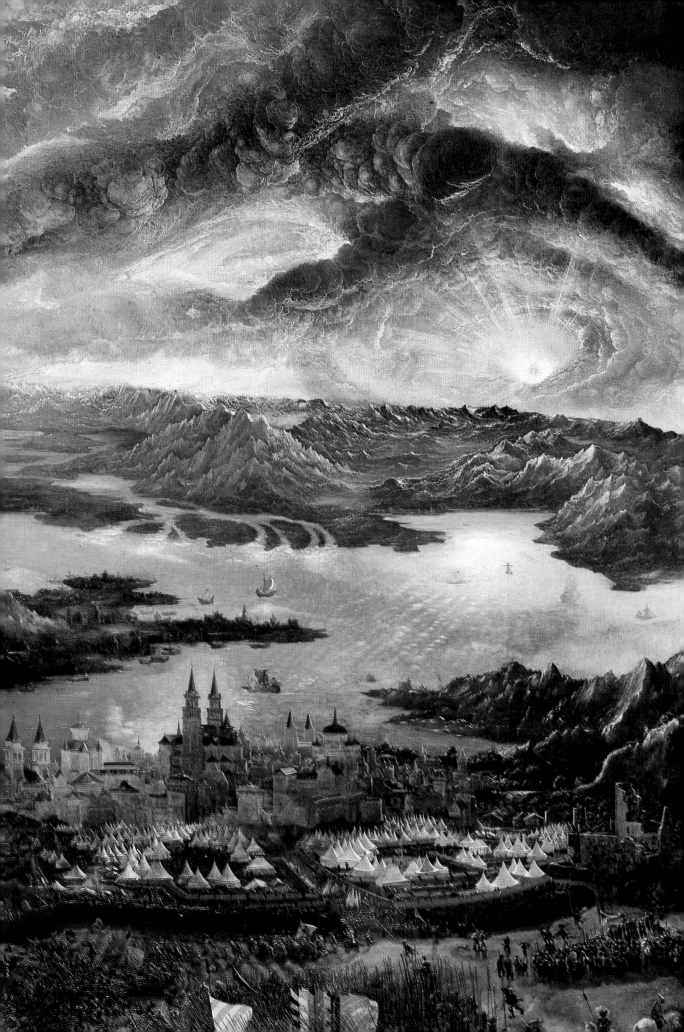

# The
# Alte Pinakothek
## Munich

Reinhold Baumstark

C.H.BECK / SCALA PUBLISHERS

FRONT COVER ILLUSTRATION
Peter Paul Rubens, detail of *Rubens and Isabella Brant in the Honeysuckle Bower*, c.1609/10
BACK COVER ILLUSTRATION
Hans Memling, detail of *The Seven Joys of the Virgin*, 1480
FRONTISPIECE
Albrecht Altdorfer, detail of *The Battle of Issus*, 1529

The introductory texts are based on the Alte Pinakothek publications listed on page 126 (catalogues). The introductory text for the chapter on Netherlandish Painting was written by Peter Eikemeier, and that on Flemish Painting by Konrad Renger.

© 2002 Scala Publishers Ltd, London
in association with Verlag C.H. Beck oHG, Munich
© Photography Bayerische Staatsgemäldesammlungen, Munich, and Artothek, Peißenberg

First published in 2002 by
Scala Publishers Limited
140a Shaftesbury Avenue
London WC2H 8HD

ISBN 3 406 47452 7

Translation by Margaret Clarke and Ulla Weinberg
Designed by Sara Robin, London

Printed and bound in Italy

# Contents

 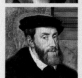

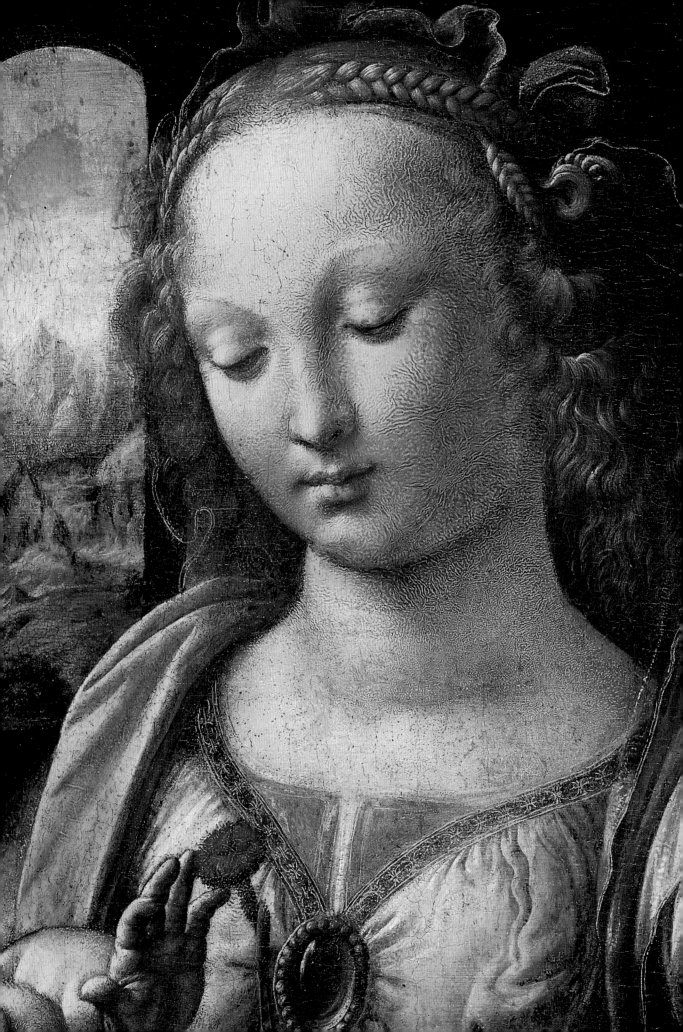

# Introduction

King Ludwig I of Bavaria (reigned 1825–48) was keen that the unique collection of paintings in Munich should have a distinctive name, and he therefore dubbed it 'Pinakothek'. This term, which the monarch had discovered in the architectural writings of the Roman author Vitruvius, became synonymous with one of the most important galleries in the world. The collection only acquired the epithet 'Alte' or 'old' (initially 'Älter' or 'older') with the creation of the 'Neue Pinakothek', which housed the 'newer' paintings of the nineteenth century.

A collection such as this, including as it does masterpieces by Dürer, Raphael, Rubens, Van Dyck, and Rembrandt, is not one that any individual could assemble on their own. Ludwig I undoubtedly made a considerable contribution to the collection: in line with the spirit of the age, which was then in the throes of rediscovering the Middle Ages and early Renaissance, he enriched the stock of older Italian, German, and Early Netherlandish paintings. In addition, with the collections in Schleissheim Palace and the Hofgarten Gallery in Munich, he had at his disposal the rich inheritance of the House of Wittelsbach — and thus already had first-class works a-plenty.

The Munich collection had been built up over centuries — not in a continuous fashion, but in alternating phases of stagnation and sudden growth. In 1528, so it is said, Duke Wilhelm IV of Bavaria (reigned 1508–50) and his consort Jacobea of Baden began decorating an imposing building in the Munich Hofgarten with a cycle of paintings depicting the great feats of men and women in world history. This cycle, which included Albrecht Altdorfer's *Battle of Issus*, has been preserved. The paintings are considered to be the core of the later Pinakothek, although they had initially been acquired as decorative pieces to convey a moral-cum-historical message, rather than for collecting purposes.

Royal collecting activities *per se* were initially reflected not in special collections divided into categories — of the kind familiar to us today — but in cabinets of curiosities that were meant to contain everything the world had to offer in the way of the artistic and the curious. Walrus tusk and rock crystal rubbed shoulders with technical apparatus, casts from nature, paintings, engravings, and drawings. Munich too had a collection of this kind, assembled in the sixteenth century. The inventory of 1598 already includes 778 paintings.

Albrecht Dürer was an early focus of collectors' attentions. Along with Emperor Rudolf II in Prague, Maximilian I (Duke and later Elector of Bavaria; reigned 1597–1651) numbered amongst the earliest collectors of his works, and of works by other German Renaissance painters. But Maximilian was also a collector of contemporary art, commissioning works from Peter Paul Rubens. In this he rivalled his relative Wolfgang Wilhelm, Count Palatine of Neuburg and Duke of Jülich-Berg (reigned 1614–53), whose patronage, motivated by religious

**Leonardo da Vinci**, detail of *The Virgin and Child*, c. 1473 (plate 57)

considerations, was later to be reflected in the Munich collection. The collection underwent considerable expansion at the end of the seventeenth century as a result of the activities of Elector Maximilian II Emanuel (reigned 1679–1726). In 1698, during his period as Stadholder of the Spanish Netherlands, he acquired a major private collection of Flemish paintings — prominent amongst which were the family portraits by Peter Paul Rubens. This must rank as one of the high points in the Wittelsbach history of collection. Max Emanuel gathered over 1,000 paintings in Schleißheim Palace, and when this was rebuilt, the plans inevitably included a 'Grande Galerie'. At about the same time, Elector Johann Wilhelm of the Palatinate (reigned 1690–1716), a grandson of Wolfgang Wilhelm, had a gallery built in his Jülich-Berg seat of Düsseldorf to house his small but choice collection of paintings. These included masterpieces by Van Dyck, Jordaens, and Rembrandt (the famous Passion cycle) and, once again, numerous paintings by Rubens — amongst them the *'Large' Last Judgement*.

Following the extinction of the Bavarian Wittelsbachs (and ultimately the Palatine line of the Wittelsbachs too), their art treasures eventually came together in Munich, along with those from other collections. In 1798, Elector Karl Theodor (reigned 1777–99) transferred 758 paintings, mainly seventeenth-century Dutch and Flemish works, from his Mannheim gallery to the Bavarian capital. In about 1780, this enlightened prince commissioned the building of the Hofgarten gallery at his residence and this, as a public gallery, became the immediate predecessor of the Alte Pinakothek. Karl Theodor's successor in the Zweibrücken line of Wittelsbachs was Elector Maximilian IV Joseph (reigned 1799–1825; from 1806 as King Max I Joseph). He too incorporated his collection. It contained a good 2,000 paintings, mainly by Dutch and French painters. In 1806 he had the Düsseldorf collection, famed as one of the finest in Europe, transferred to Munich.

In this period of major social and political upheaval, during which modern-day Bavaria took shape, an administrative reform was instituted which also affected the art collections. Under the name 'Bayerische Staatsgemäldesammlungen' (Bavarian State Paintings Collections), a central authority was formed which continues, even today, to have charge of the paintings owned by the state. From 1803 onwards about 1,500 paintings were added, following the secularization of church assets in Bavaria and of the territories that had become Bavarian. The almost unmanageable number of paintings that resulted made some kind of decentralization necessary, and this principle persists today in the system of Bavarian 'branch galleries'.

It was this collection — expanded by the Italian acquisitions that he himself had made as crown prince — over which Ludwig I had control at the time the foundation-stone of the Alte Pinakothek was laid. In 1827 and 1828, he was able to expand the German Renaissance section by more than 400 major works, through the addition of the Oettingen-Wallerstein and Boisserée collections; and it was as a result of this purchase that the Early Netherlandish collection was first formed. The acquisitions policy in subsequent years — and indeed up to the present time — was always geared to securing major individual works as a way of expanding the collection. The conspicuous lack of eighteenth-century works, which were not very highly regarded in Ludwig's time, was made good in the second half of the twentieth century through generous loans from Munich-based financial institutions (special mention should be made here of the former Bayerische Hypotheken- und Wechselbank, and also of the Bayerische Landesbank).

The Alte Pinakothek, begun in 1826 and inaugurated in 1836, blazed the trail for nineteenth-century museum construction. Its very location — 'out in the country', in the thinly populated Maxvorstadt area of Munich — was unusual. It meant the abandonment of the tradition whereby galleries were attached to palaces or castles. The structure of the building was derived entirely from its internal functional lay-out. There was no recourse to formulaic

pomposity. Another innovative feature was the use of High Renaissance style to produce, as it were, an architectural statement that not only housed the history of art, but depicted it in decorative paintings and sculptures inside and outside the building.

As a museum building, the (Alte) Pinakothek was the product of a fruitful collaboration between two specialists on whom the king was able to call — the architect Leo von Klenze and the then director of the gallery, Johann Georg von Dillis. Much of their pioneering thought still makes itself felt today, such as the now clearly obvious division into large halls and smaller cabinet-style rooms, plentiful daylight in the interior, and overhead lighting, which frees up wall space for the paintings and ensures illumination without dazzle. The way in which paintings are presented in most art galleries in the world can also be traced back to the ideas of Dillis and Klenze. Following the example of the Louvre, the division into 'schools' and periods ensures that justice is done to the achievements of the artists, who were working under very varied conditions. The catalogue, published as early as 1838, reveals that conservation criteria which are still valid today — such as constant atmospheric conditions and protection from dust — had already been taken into account in the construction of the Pinakothek.

Much has changed since the time of Klenze, Dillis, and King Ludwig. The gallery's creators would search in vain for the original entrance and lobby on the east side, facing Barerstraße. Two lions on either side of the stairway recall the old configuration. Visitors would miss the painted, richly stuccoed loggia on the upper storey on the south side of the building. The heavy, partly gilded stucco in the large gallery-rooms has disappeared. Both the collection of antique vases on the ground floor of the west wing, affording a wider glimpse into the story of art, and the collection of drawings and engravings, are no longer to be found here. The outside of the building formerly bore a distinctive series of statues of major artists on its southern side, and an overhead-lighting structure on its roof, visible far and wide.

Today's Alte Pinakothek is largely the result of the reconstruction carried out under the architect Hans Döllgast after the Second World War. In 1957, the building, which suffered severe bomb damage, was reopened after construction work lasting four years. This was followed, in 1961 and 1964, by the conversion of the east and west basements. The effects of the damage that occurred during the war are still visible on the outer façade. A particularly impressive feature is the imposing stairway which, with its untrammelled grandeur and light-drenched airiness, brings a new tone to the building and could, without exaggeration, be thought of as a symbol of democratic openness. Architectural historians have come to appreciate the Alte Pinakothek as a classic example of German architecture of the reconstruction period.

The creators of the Alte Pinakothek were concerned that the gallery should not appear isolated, and this thought has continued to bear fruit up to the present day. The visitor finds the Alte Pinakothek ensconced in what is surely a unique museum-dominated environment. With the Neue Pinakothek, and shortly also the Pinakothek der Moderne, on the one side, and the Glyptothek — also built by King Ludwig — and Collection of Antiquities on the other, the result is an ensemble that offers a panorama of art from the beginnings of European history right up to the present time.

Reinhold Baumstark

# Early Netherlandish Painting

The small but select collection of Early Netherlandish painting in the Alte Pinakothek comprises works from the artistically fruitful period from the mid-fifteenth century to the 1620s — mostly from Flanders and Brabant, the two northerly provinces of present-day Belgium whose influence was then predominant. Bruges and Ghent, Brussels, Louvain, and later Antwerp were centres of trade and commerce, in which the arts also flourished.

Some of these pictures had found their way to Germany at quite an early date as a result of the close trade relations, through the Hanseatic League, between the city of Cologne and the Netherlands, where works were commissioned and painted for Cologne churches. Deprived of their original homes as a result of the secularization of ecclesiastical estates at the beginning of the nineteenth century, they came into the possession of the brothers Melchior and Sulpiz Boisserée, dedicated Cologne collectors whose appreciation of art had been shaped by the enthusiasm of romantic poets and philosophers for the hitherto little esteemed 'primitive' art of the Middle Ages. This collection was purchased by King Ludwig I of Bavaria in 1827 and its rich contents became a cornerstone of the Alte Pinakothek.

The oldest work in the Early Netherlandish section, and at the same time the outstanding focal point, is *The Adoration of the Magi Altarpiece* (plates 2, 3) from St Columba's in Cologne, painted by the official town painter of Brussels, Rogier van der Weyden, around 1455. Harmony of line and purity of colour are evidence of the heights of spiritual and artistic perfection achieved by this school in its finest moments.

The art of Dieric Bouts, on the other hand, is, as Max J. Friedländer observed, 'more concerned with the emotions'. This painter, working in Louvain, was one of the first to include the atmospheric values of landscape and of the changing light at different times of day in his paintings. In the *Pearl of Brabant* (plate 4), the exquisite small household altar belonging to a Louvain patrician family, this element of expressiveness becomes the determining factor of the pictorial composition. The miniature-like delicacy of the painting, the soft, jewel-like brightness of the colour and the striking immediacy of the rendering combine in this work to give an enchanting effect, accentuated by the picture's impeccable state of preservation. The same is true of the painting *Ecce Agnus Dei*, which was added to the collections in 1989 and may be regarded as one of the most fortunate acquisitions since that of the Boisserée collection.

Hans Memling, a native of the Middle Rhine area who came to fame in Bruges, is also represented by a major work in the collection. The wide, panoramic landscape of *The Seven Joys of the Virgin* (plate 6), which provides scope for a number of biblical and legendary episodes from the lives of Christ and the Virgin, was formerly an

1 **Dieric Bouts**, detail of *John Points to Jesus* (plate 5)

altar panel in a small chapel in the Frauenkirche in Bruges. In the course of an eighteenth-century modernisation it was considered to be outmoded, was removed, and came into the possession of the Empress Josephine Beauharnais. Later it came into the hands of the Boisserée brothers through the art market. Since then this gem of unspectacular, tenderly intimate narrative skill has become one of the pieces most admired by the public in the collection. The rather middle-class, decent character of Bruges art, which at the same time contains a certain comforting warmth, is again expressed in the romantic *The Rest on the Flight into Egypt* by Adriaen Isenbrant (plate 11) who, through the influence of Gerard David, could be seen as a follower of Memling.

Although the paintings which had belonged to the Boisserée brothers form the nucleus of the Early Netherlandish stocks in Munich, there were already a few significant works from this area in the collection before their acquisition, and others followed later. Elector Maximilian, although a passionate admirer of Dürer, had by no means confined his interest to the work of the Nuremberg master. His collector's enthusiasm was also directed towards Dürer's German and Netherlandish contemporaries who, like Dürer, had portrayed man in his newly won freedom and responsibility as an individual, having shaken off his cramping medieval fetters. Among the Early Netherlandish paintings housed in the private gallery in the Residenz in Munich was the panel with the figures of the Emperor Constantine and his mother St Helen — presumably a fragment of a larger altar work. This panel by the Leyden painter Cornelis Engelbrechtsz is remarkable both iconographically and in the expressive style of its figures. Lucas van Leyden, an important disciple of Engelbrechtsz, is represented with a diptych, *Virgin and Child with St Mary Magdalene and Donor* (plate 12). This work, reminiscent of Dürer and outstanding in its high artistic quality, had formerly been in Emperor Rudolf II's collection in Prague and then in the possession of Maximilian, his keenest rival in collecting. It is now not possible to trace its path to Munich, although some kind of exchange of paintings seems likely. At all events, on its arrival there it was altered, like numerous other pictures in Maximilian's collection, by merging the two parts of the diptych into one and trimming the top to form a rectangular panel. (Parts of the addition were later removed.)

The *Danae* by Jan Gossaert (plate 14) also came from the imperial collection in Prague, although it is only recorded as being in Munich from the middle of the sixteenth century. This highly artificial work aptly characterizes the situation in which the artists of the North found themselves during the first decades of the sixteenth century. With their roots in their native tradition, they were confronted by the new ideas of the Renaissance which were streaming in, ever more powerfully, from Italy. These ideas reveal themselves here not only in the themes depicted, but also in the sense of figures and space.

Hieronymus Bosch's infernal portrayal of *The Last Judgment* (plate 10), of which only a relatively small fragment has survived from a panel which probably originally measured several square metres, comes from a world peopled by creatures completely unknown to human evolution. It is recorded as being in the collection since the early nineteenth century, originating from an unknown source.

2  **Rogier van der Weyden**, detail of *The Adoration of the Magi Altarpiece* (plate 3B)

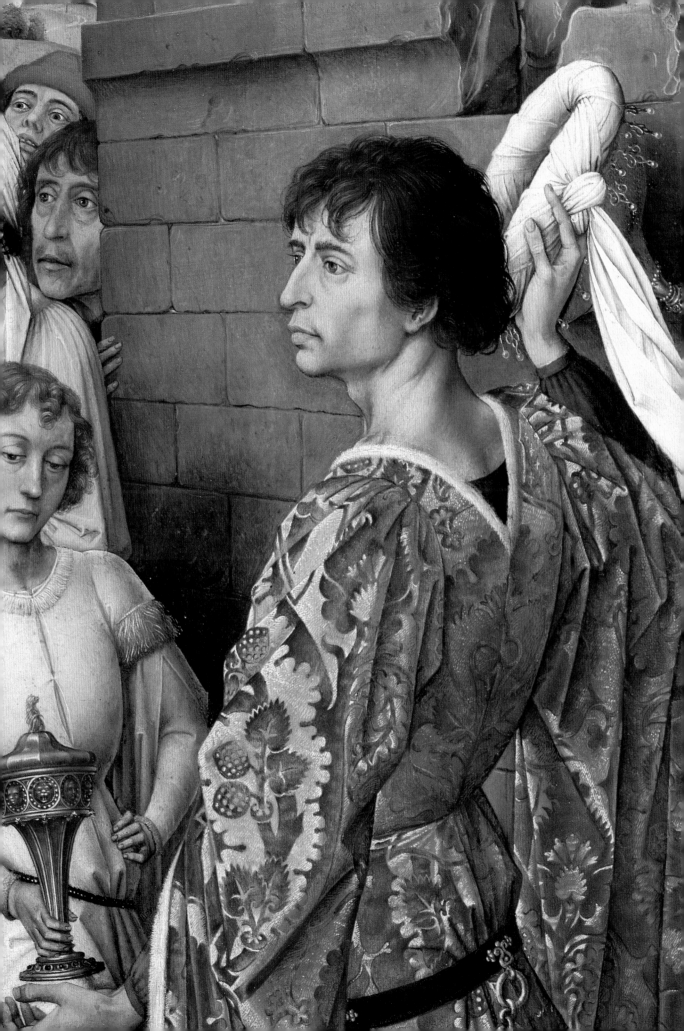

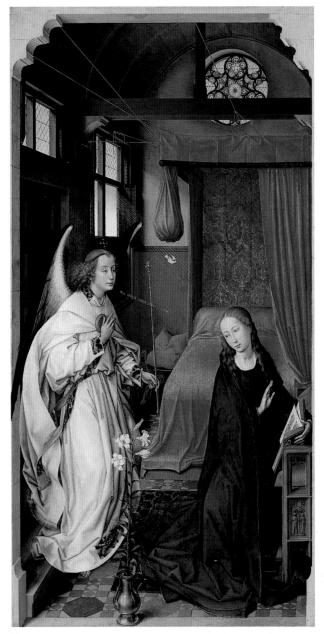

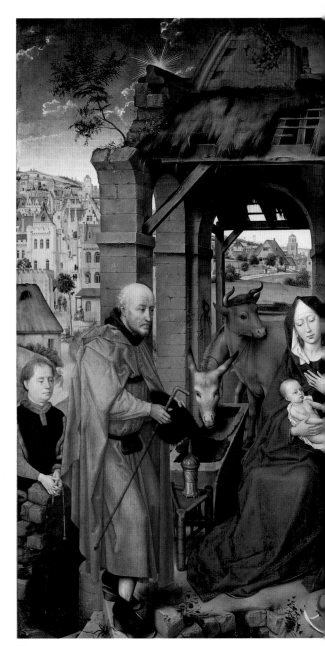

3A

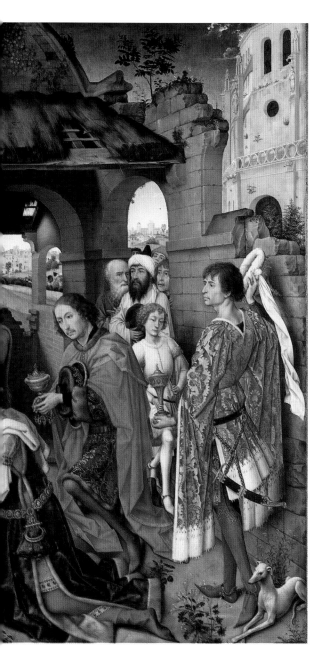

3C

3 A-C
**Rogier van der Weyden**
Tournai 1399/1400–
Brussels 1464
*The Adoration of the Magi
Altarpiece (Columba Altar)*
c. 1455
Oak
138 x 153 cm (central panel)
[WAF 1189]

LEFT: *Annunciation*
CENTRE: *Adoration of the Magi*
RIGHT: *The Presentation in the
Temple*
The triptych was not intended to
be closed, as the reverse sides of
the altar wings are not painted.
It was donated to St Columba's
in Cologne by Goedert von dem
Wasserfuss, the Bürgermeister

(Mayor) of Cologne. After the
Dissolution, the altar, which
must rank as one of the major
works of Early Netherlandish
painting, found its way into the
Boisserée collection, where
Goethe admired it. This
collection was purchased by King
Ludwig I in 1827.

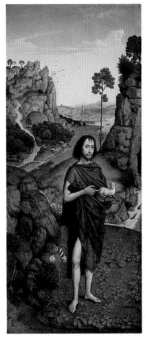

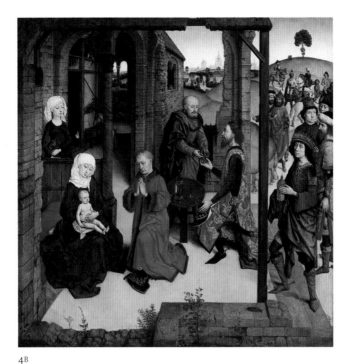

4A

4B

4C

**4 A-C**
**Dieric Bouts**
Haarlem 1410/20–Louvain 1475
*'Pearl of Brabant' Altarpiece*
Altarpiece with side wings
*c.* 1470
Oak
62.6 x 62.6 cm (central panel)
[WAF 76]

LEFT: *John the Baptist*
CENTRE: *Adoration of the Magi*
RIGHT: *St Christopher*

The triptych, which no doubt once served private devotion, is striking due to its atmospheric, enamel-like colouring shining from the depths. The name 'Pearl of Brabant' has only been in use since the beginning of the 20th century. Purchased by the Boisserée brothers from a private owner in Malines in 1813, it was acquired by King Ludwig I with the Boisserée collection in 1827.

**5**
**Dieric Bouts**
Haarlem 1410/20–Louvain 1475
*John Points to Jesus: 'Behold, the Lamb of God',*
*c.* 1462/64
Wood
53.8 x 41.2 cm
[15192]

Acquired in 1989 with the assistance of the Kulturstiftung der Länder, this was formerly in the collection of Eugène de Beau-

harnais, Duke of Leuchtenberg. 'Behold, the lamb of God,' exclaimed John (John 1: 29 and 36) when he saw Christ on the banks of the Jordan; whereupon the first apostles got up and followed the Messiah. Here the scene has been translated into a private devotional picture, with John figuring as patron to the unknown donor. The outstanding quality of this masterpiece by the Louvain painter is captivating.

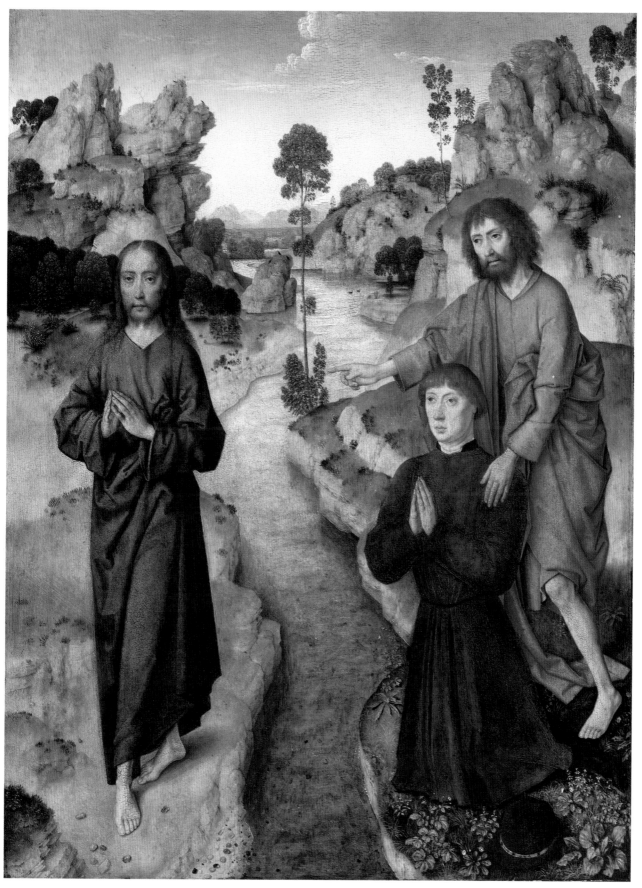

6
**Hans Memling**
Seligenstadt/Main
*c.* 1435/40–Bruges 1494
*The Seven Joys of the Virgin*
1480
Oak
81 x 189 cm  [WAF 668]

This painting was donated by Pieter Bultnyc and his wife Katharina von Riebeke to the chapel of the tanners in the Frauenkirche in Bruges. No doubt inspired by medieval mystery plays, twenty-five separate incidents from the story of Mary, including the 'Seven Joys' (in contrast to the 'Seven Sorrows'), are clearly divided over a panoramic landscape with raised horizon. In Empress Josephine Beauharnais' collection in 1804, it was purchased by King Ludwig I with the Boisserée collection in 1827.

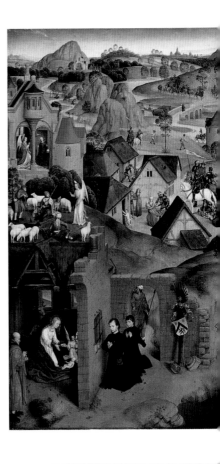

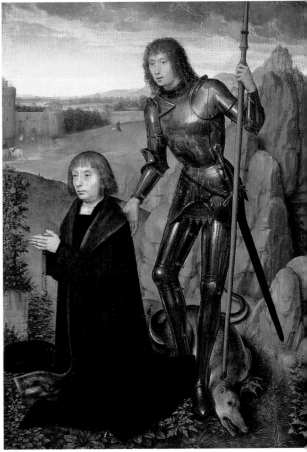

7A

7B

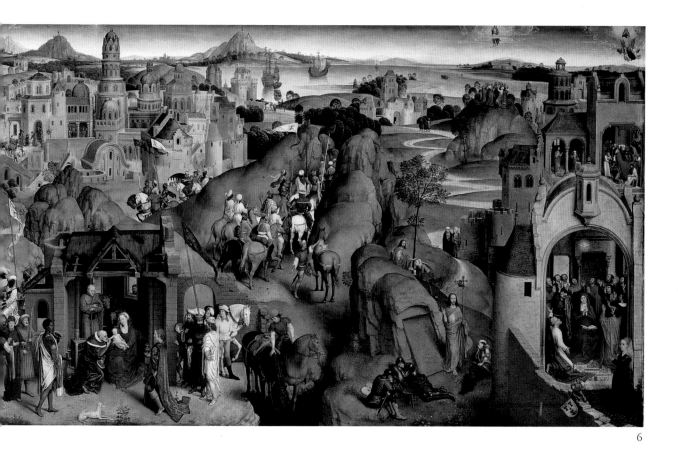

6

7 A-B
**Hans Memling**
Seligenstadt/Main
c. 1435/40–Bruges 1494
*Mary in the Rose Bower –*
*St George with the Donor*
Inside of a diptych
c. 1480
Oak
43.3 x 31 cm (each wing)
[680, 5]

The outside of the left wing is
unpainted, that of the right wing
has been detached and shows
St Anne with Mary and the infant
Jesus. Such diptychs, with portraits
of their donors, were widespread
in the late Middle Ages and served
for private devotion. They are
thus a testimony to changing
religious sentiments at the time.
From the Zweibrücken gallery.

8
**Jean Hey**
Working in Burgundy 1483/1501
*Charles II of Bourbon as a*
*Cardinal*
c. 1482/83
Oak
34 x 25 cm  [WAF 648]

Charles II was the third son of
Duke Charles I and Agnes of
Burgundy. He was appointed
cardinal in 1476. Purchased with
the Boisserée collection by King
Ludwig I in 1827.

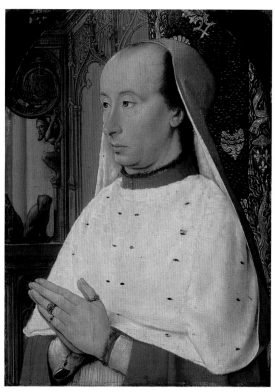

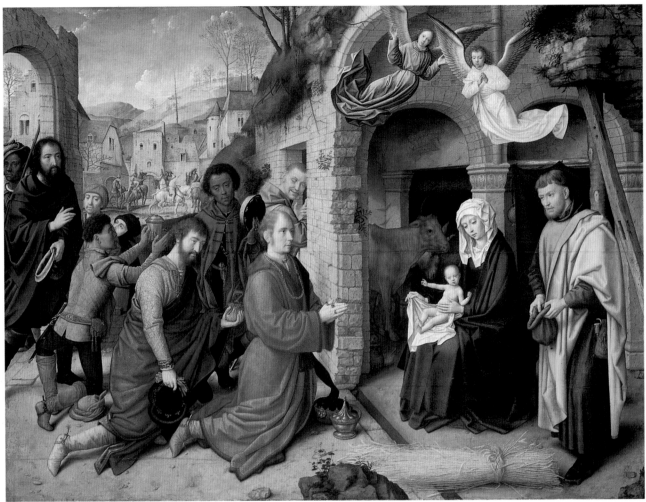

9

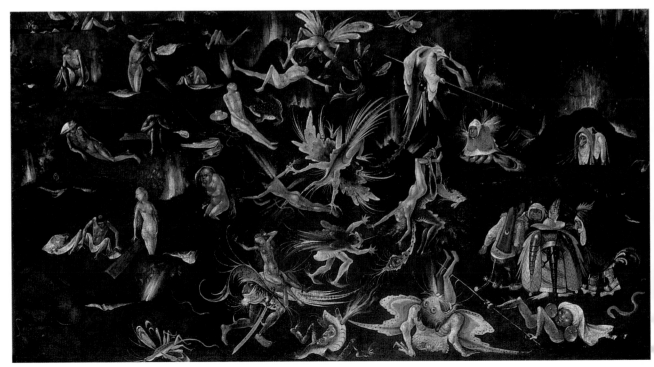

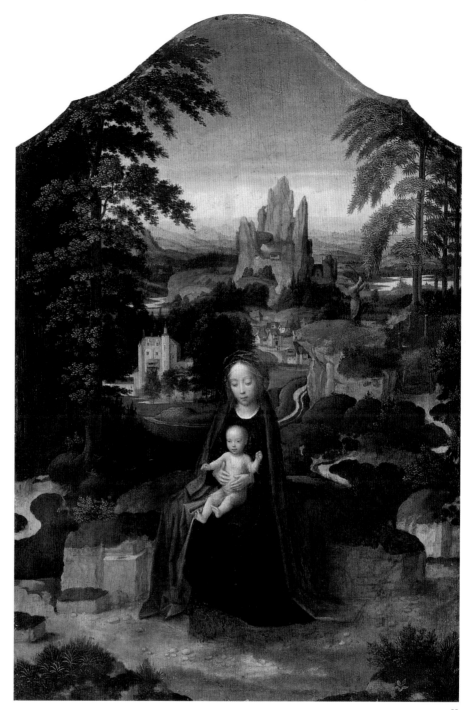

11

9
**Gerard David**
Oudewater (Holland)
*c.* 1460–Bruges 1523
*The Adoration of the Magi*
*c.* 1490/95
Oak
123 x 166 cm [715]

Copy of a lost work by Hugo van
der Goes, probably painted about
1480. Here the figures are
imbued with a new gravity.
Purchased by Crown Prince
Ludwig from a private collection
in Paris in 1816.

10
**Hieronymus Bosch**
's-Hertogenbosch 1450–
's-Hertogenbosch 1516
*The Last Judgment* (fragment)
beginning of 16th century
Oak
59.4 x 112.9 cm [5752]

Fragment (right lower part) of
a no longer traceable large-scale
picture of the Last Judgment
which shows the resurrection
of the dead in a fantastic and
surreal manner. Known to have
been in the reserve of the branch
gallery in the castle of Nuremberg
from 1817 onwards.

11
**Adriaen Isenbrant**
birthplace unknown
*c.* 1490–Bruges 1551
*The Rest on the Flight into Egypt*
*c.* 1520/30
Oak
49.5 x 34 cm [WAF 398]

The landscape uses devices by
the Antwerp painter Joachim
Patinir, and the figures have been
influenced by Gerard David. The
childlike, fairy-tale atmosphere,
however, reveals Isenbrant's own
charming manner of expression.
Purchased by King Ludwig I with
the Boisserée collection in 1827.

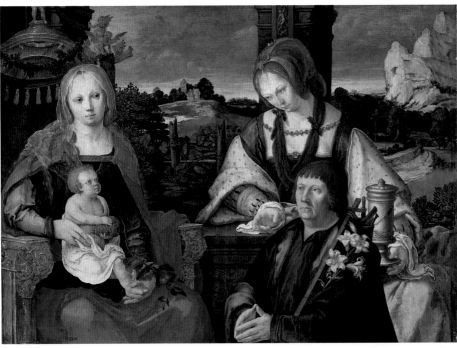

12

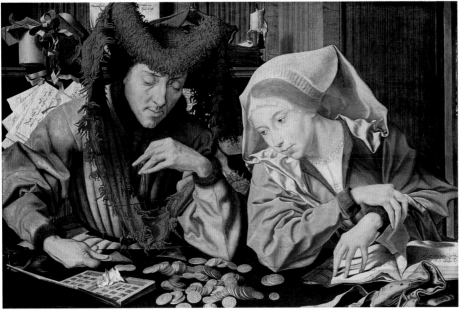

13

12
**Lucas van Leyden**
Leiden probably 1494–
Leiden 1533
*Virgin and Child with St Mary Magdalen and Donor*
signed and dated 1522
Oak
50.5 x 67.8 cm  [742]

Originally a diptych with rounded upper edge, the paintings were later combined to form a panel and cut straight across the top. *The Annunciation*, detached from the right wing in 1874, is also in the Alte Pinakothek. The donor was probably changed into St Joseph by the addition of suitable attributes in the early 17th century. The painter has made creative use of Venetian ideas and Dürer's prints in equal measure. According to Van Mander, the painting was in Emperor Rudolf II's collection. From the private gallery of Elector Maximilian I.

13
**Marinus van Reymerswaele**
Reymerswael (Zeeland) *c.* 1490–
later than 1567
*A Tax Collector with His Wife*
signed and dated 1538
Oak
67 x 103 cm  [7]

According to the inscription, this depicts a tax collector named Boisselaer. The painting, of which there are other slightly different variants, stems from a picture by Quinten Massys in the Louvre in Paris dated 1514. From the collection of Elector Maximilian I.

**14**
**Jan Gossaert**
Maubeuge (Hennegau)
*c.* 1478– Breda 1532
*Danae*
signed and dated 1527
Oak
113.5 x 95 cm  [38]

Danae receives the golden rain of
Zeus, which led to the conception
of Perseus. In contrast to the more
sensual treatment of the theme
in the Italian Renaissance, where
Danae is shown naked, Gossaert
remains committed to the
medieval tradition which construed
the theme moralistically, as an
allegory of chastity. Known to have
been in the Elector's gallery from
1748 onwards.

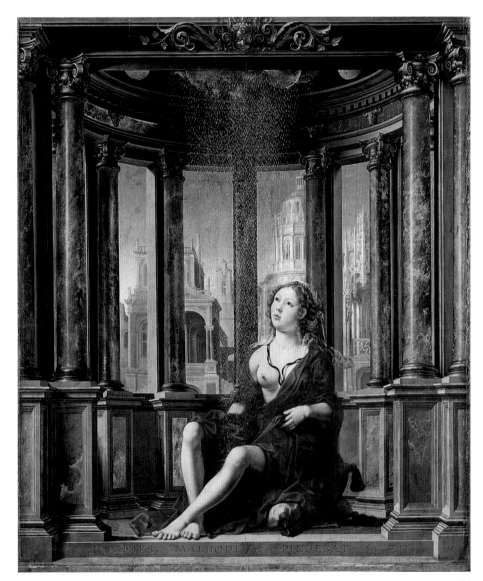

14

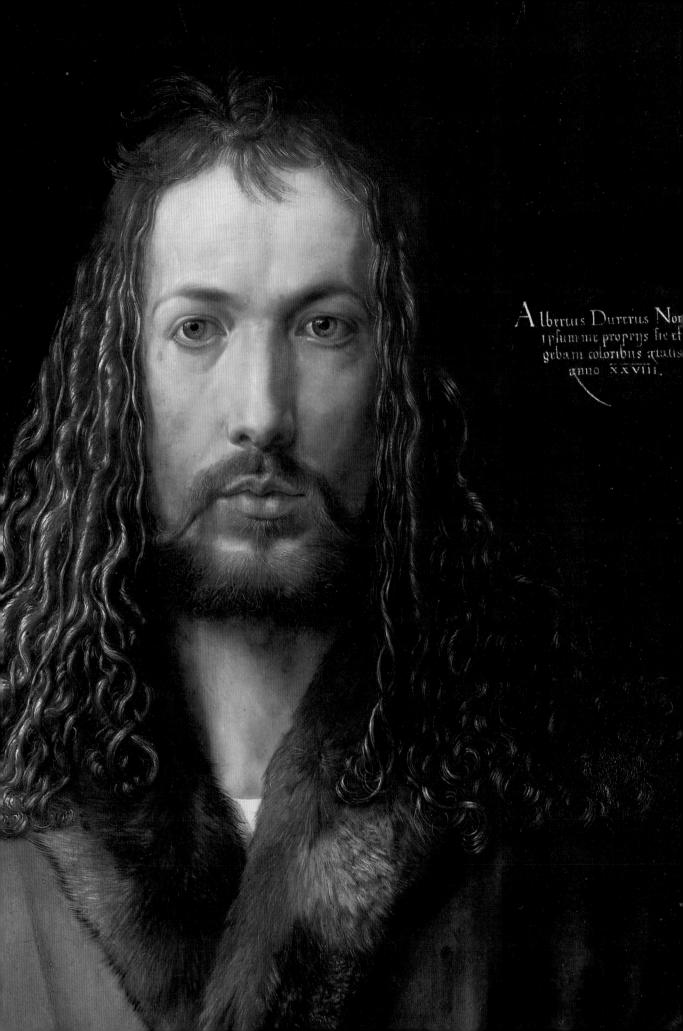

ALbertus Durerus Nor
iphum me propriis sic et
gebam coloribus ætatis
anno XXVIII.

# German Painting

The Alte Pinakothek contains the most extensive and most distinguished collection of German painting from the late Gothic and Dürer periods. Two series of biblical and secular history paintings with ideal heroes representing virtues, commissioned by Duke Wilhelm IV from the most notable Bavarian, Swabian and Franconian artists from 1528 onwards, were some of the finest paintings to be acquired by the House of Wittelsbach. Among these, *The Battle of Issus* by Albrecht Altdorfer (plate 38) stands out as a high point of European painting. Wilhelm IV also distributed numerous commissions for portraits. From 1530 onwards Barthel Beham painted a series of Bavarian–Palatine portraits, of which several panels have been preserved. Altdorfer's *Susanna and the Elders* (plates 39, 41) of 1526 may also be numbered amongst Wilhelm's paintings with a high degree of probability — dating, coats-of-arms and other indications point to its having been one of the authenticated pictures in his possession.

Elector Maximilian I has already been described as the most passionate collector of his generation, and a devotee of the works of Dürer. The acquisition of Dürer's *Lamentation* (plate 28) was his first successful transaction; in 1613 the *Paumgartner Altar* was secured for Munich, and in 1627 he achieved his greatest triumph in acquiring *The Four Apostles* (plate 30), which Dürer had presented to his native town of Nuremberg a hundred years earlier. The inventory, begun in 1627 and kept until around 1630, shows that Maximilian amassed no fewer than eleven works by Dürer. Although his interest in other Early German masters was less keen, he did purchase four Cranach paintings, followed by the *St John Altarpiece* (plate 26); a small *Madonna* (now on loan to the German National Museum, Nuremberg), both by Burgkmair the Elder; and *The Fount of Life* by Holbein the Elder (now in Lisbon).

During the Baroque period, under the rulers from Elector Ferdinand Maria (reigned 1651–1679) up to Max I (reigned 1799–1825), no substantial additions were made in the sphere of Early German painting. In his time as Stadholder of the Netherlands, and later also as an émigré in France, Max Emanuel (reigned 1679–1726) showed a fondness for Baroque art — particularly Flemish painting, but also Italian, Dutch and French works. No evidence has yet emerged of there having been any Early German pictures amongst his numerous acquisitions.

Subsequently, no further major additions were made to the collections of Early German painting until the advent of secularization in the early nineteenth century. About 240 paintings from monasteries and abbeys entered the collections of what was then the 'Zentralgemäldegalerie' as a result of these events. It is remarkable that this period, in which art collections were being centralized, should have been the one to see the birth of the idea of decentralization — which persists to this day in an extensive network of state-run 'branch galleries'.

King Max I's eldest son, Crown Prince Ludwig, was involved with genuine devotion and unquestionable

affection in the building up and extending of the collection to a degree far exceeding mere amateurishness. The Early German section of the Alte Pinakothek is indebted to Ludwig's collecting zeal, and to the conoisseurship of the highly experienced gallery director Georg von Dillis, for Dürer's famous self-portrait of 1500 (plates 15, 27), his *Portrait of a Young Man* and the likeness of his teacher Wohlgemut (on loan to the German National Museum in Nuremberg), and also for Altdorfer's *The Birth of the Virgin* (plate 33), the *St Sebastian Altarpiece* by Hans Holbein the Elder, Burgkmair's *Crucifixion Altarpiece* and his portrait of Schongauer.

In 1827, very soon after his accession to the throne, King Ludwig purchased out of his privy purse — and in competition with Stuttgart — the 213 Early German and Early Netherlandish panels of the Boisserée collection which had once been admired by Goethe. This meant that Cologne painting — from the Master of St Veronica to Stephan Lochner, and the Master of the Life of the Virgin right up to Bartholomeus Bruyn the Elder — was represented with a completeness comparable only to that achieved in the Wallraf-Richartz Museum. To these purchases were added the wings of the *Jabach'sche Altar* and *The Holzschuher Lamentation* by Dürer (on loan to the German National Museum, Nuremberg), Altdorfer's forest picture with St George, the Anna Selbdritt portrait by Lucas Cranach the Elder, and other important pieces. In the following year came the purchase of the Oettingen-Wallerstein collection, which had been based on the same Romantic ideals as those of the Boisserée brothers. Paintings by Dürer (*Portrait of Oswolt Krel*) and Altdorfer (*Danube Landscape*), and a number of works from Swabia and Cologne, changed hands.

In the twentieth century, two names above all left their mark on the Early German collection: that of Friedrich Dornhöffer, director of the Bayerische Staatsgemäldesammlungen from 1914 to 1933, and that of his successor, Ernst Buchner, who served until 1945. Both made a number of important acquisitions, including portraits by Christoph Amberger, Martin Schaffner and Hans Baldung, as well as works by anonymous masters of the late Middle Ages. This, as it were, brought the formation of the Early German collection to a provisional close.

German Baroque painting can boast only a few masters of international stature. The three Adam Elsheimer paintings on display, among them the famous *Flight into Egypt* (plate 47), came from the Düsseldorf gallery and from the private gallery of Elector Maximilian I. *The Death of Cleopatra* by Johann Liss (plate 45) was one of the later arrivals in the gallery, acquired by Kurt Martin in 1964.

16
**Stephan Lochner**
Meersburg on the Bodensee (?)
*c.* 1400/10–Cologne 1451
*The Virgin Worshipping the Child*
1445
Oak
37.5 x 23.6 cm [13169]

REVERSE: *Christ on the Cross.*
Originally part of a diptych or
triptych. Related panels, with the
*Presentation of Christ in the Temple*
on the inside and *St Francis
Receives the Stigmata* on the
outside, are in the Gulbenkian
collection, Lisbon. Having been
in the Hermann Göring collection,
this panel was transferred to the
property of the Free State of
Bavaria in 1945.

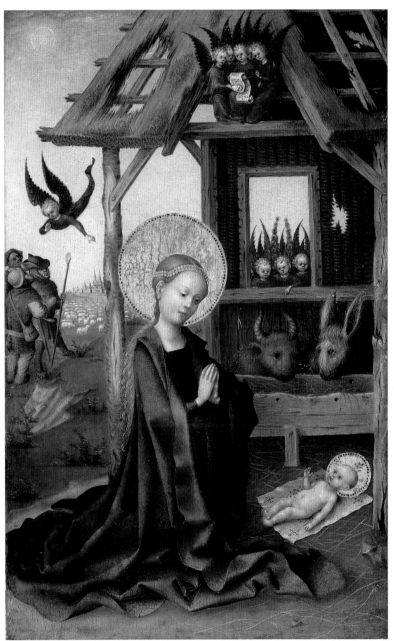

16

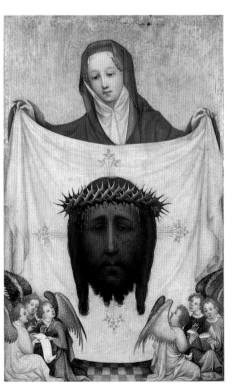

17

17
**Master of St Veronica**
working in Cologne in the first
quarter of the 15th century
*St Veronica with the Sudarium*
*c.* 1420
Pinewood covered with canvas,
gilded background
78.1 x 48.2 cm [11866]

A major work of the late Gothic
school of painters before Stephan
Lochner. From St Severin's, Cologne.
Purchased by King Ludwig I in
1827 with the Boisserée collection.

**18**

**Master of the Polling Panels**
working for the church of the
Augustine Canons in Polling
near Weilheim (Upper Bavaria)
*c.* 1440/50
*The Annunciation*
dated 1444
Pinewood
129.5 x 86 cm  [6247]

Upper part of the outside of
a wing from a Lady-altar in the
church of St Salvator and the
Holy Cross. The other wing is in
the German National Museum
in Nuremberg. The central part
of the altarpiece, presumably
carved, has been lost. According
to the coat-of-arms, this was the
bequest of Duke Albrecht III of
Bavaria and his wife Anna,
daughter of Duke Erich I of
Braunschweig-Grubenhagen.
Brought from Polling to Munich
in 1803 when the church was
secularized.

**19**

**Master of the Life of the Virgin**
working in Cologne *c.* 1460–90
*The Presentation of the Virgin*
from a series of pictures
representing the life of the Virgin
(altarpiece with wings)
*c.* 1460/65
Oak, gold ground
85 x 105 cm  [WAF 620]

The three-year-old Mary climbs
the staircase of fifteen steps, after
Joachim and Anna have taken a
vow to consecrate their child to
the service of God. Six additional
panels are in the Alte Pinakothek,
while an eighth painting is in the
National Gallery, London.
Purchased by King Ludwig I with
the Boisserée collection.

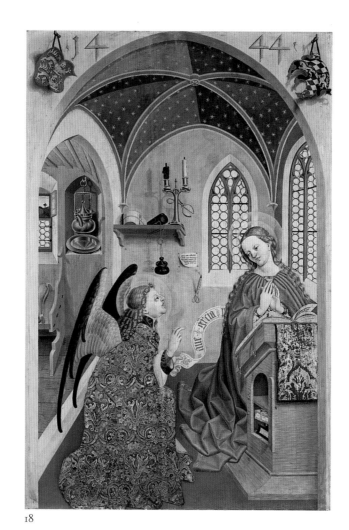

18

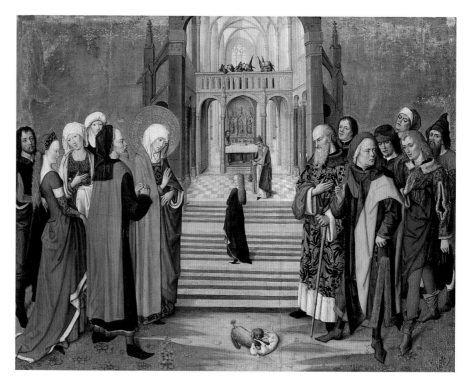

19

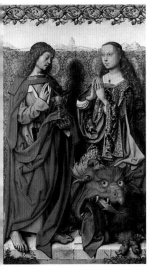

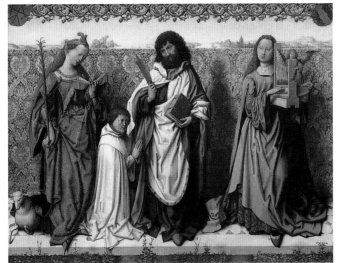

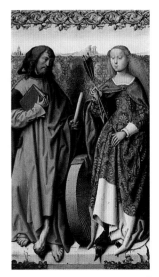

20A

20B

20C

20A-C
**Master of the Bartholomew Altar**
working mainly in Cologne
*c.* 1475–1510
*Bartholomew Altar*
*c.* 1500/10
Oak
129 x 161 cm [11863]

LEFT: *St John the Evangelist and St Margaret*
CENTRE: *Saints Agnes, Bartholomew and Cecilia with a Carthusian Donor*
RIGHT: *St James the Younger and St Christina*

Painted late in the artist's life, this was the last monumental altarpiece of late Gothic painting in Cologne. Puchased by King Ludwig I with the Boisserée collection, the altar having come from St Columba in Cologne.

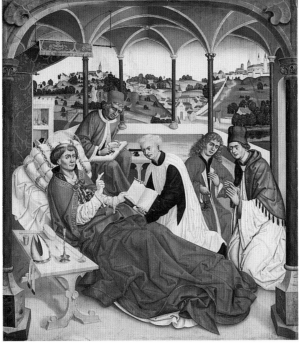

21

21
**Jan Polack**
a native of Poland (Cracow?)
in the Munich area from 1479–
Munich 1519
*The Death of St Corbinian*
*c.* 1483/89
Pinewood
147 x 129 cm [1402]

From the high altar (lower part of the inside of the left wing) of the former Benedictine monastery church in Weihenstephan, near Freising. Other parts of the great polyptych are in the Alte Pinakothek and in the Diocesan Museum in Freising. This depiction of the city of Freising. and of the Domberg from the south, is true to life. Brought to Munich from Weihenstephan in 1804 when the monastery's property was dispersed.

22

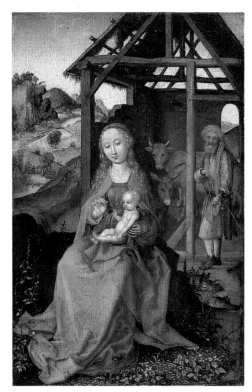

23

22
**Michael Pacher**
probably Bruneck *c.* 1435–
Salzburg 1498
*Church Fathers' Altar*
*c.* 1480
Cedar wood
382 x 91 cm (total size when
open) [2597-2600]

When opened, the central panel
and wings show the four Church
Fathers (Jerome, Augustine,
Gregory and Ambrose) under
painted baldachins. The outsides
of the wings show scenes from
the life of St Augustine. Painted
for the church of the Augustinian
Canons Neustift near Brixen.
Brought to Munich in 1812 when
the church's contents were
dispersed.

23
**Martin Schongauer**
Colmar (?) *c.* 1450–Breisach 1491
*The Holy Family*
*c.* 1475/80
Limewood
26 x 17 cm [1132]

Mary hands the infant a wild
chicory, which, according to late
medieval flower symbolism,
possessed powers to ward off evil.
From the Zweibrücken gallery.

24
**Michael Pacher**, detail of *Church
Fathers' Altar* (plate 22)

25

25
**Hans Holbein the Elder**
Augsburg *c.* 1460/65–Basle
or Isenheim (?) 1524
*St Sebastian Altarpiece*
1516
Limewood
153 x 107 cm (central panel)
[5352, 668, 669]

CENTRAL PANEL: *The Martyrdom of
St Sebastian* (above)
LEFT WING: *St Barbara*
RIGHT WING: *St Elizabeth with
Three Beggars*
ON THE OUTSIDES OF THE WINGS IN
GRISAILLE: *The Annunciation*
One of the earliest Renaissance
works in South German painting.
Became state property after being
taken from the Jesuit church of
St Salvator in Augsburg when the
church property was dispersed in
1809.

26

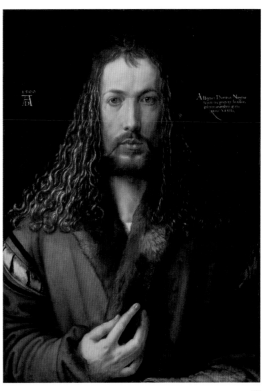

26
**Hans Burgkmair the Elder**
Augsburg 1473–Augsburg 1531
*St John Altarpiece*
signed and dated 1518
Pinewood
153.1 x 127.2 cm (total dimension)
[685]

LEFT (INSIDE): *St Erasmus*
CENTRE: *St John the Evangelist on Patmos*
RIGHT (INSIDE): *St Martin*
The separated outsides of the
wings show John the Baptist on
the left and John the Evangelist
on the right. From the private
gallery of Maximilian I.

27
**Albrecht Dürer**
Nuremberg 1471–Nuremberg 1528
*Self-portrait*
signed and dated 1500
Limewood
67 x 49 cm [537]

The style of full-face, symmetrical
representation had hitherto been
reserved exclusively for the image
of Christ (Vera icon). The translation
of the Latin inscription runs: 'Here I
have painted myself Albrecht Dürer
of Nuremberg, in imperishable
colours, at the age of 28'. Acquired
in Nuremberg in 1805.

27

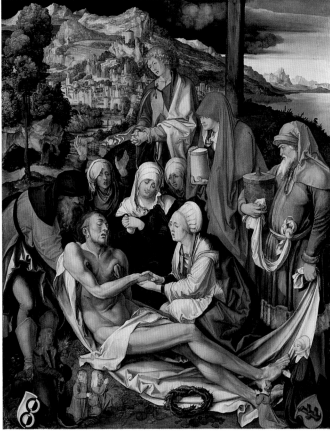

28

28
**Albrecht Dürer**
Nuremberg 1471–Nuremberg
1528
*Lamentation*
signed and dated probably 1500
Pinewood
151 x 121 cm [704]

At the bottom left and right are
the donors Albrecht Glim and
his first wife Margareth, née
Holzmann (d. 1500), with two
sons and a daughter, together with
their coats-of-arms. Albrecht Glim
was a respected Nuremberg
goldsmith. Probably donated to
the Prediger church in Nuremberg,
the painting was purchased by
Duke Maximilian I of Bavaria
from the Imhoff collection
between 1598 and 1607.

29
**Albrecht Dürer**
Nuremberg 1471–Nuremberg
1528
*Paumgartner Altarpiece*
signed, probably 1502/4
Limewood
155 x 126 cm [706]

CENTRAL PANEL: *The Birth of Christ*
(with the Augsburg and
Nuremberg patrician family of
Paumgartner as the donors,
together with their coats-of-arms;
left)
LEFT WING (INSIDE): *St George*
(OUTSIDE): *Virgin of the Annunciation*
(IN GRISAILLE)
RIGHT WING (INSIDE): *St Eustachius*
*The Angel of the Annunciation*
from the outside has not
survived. Purchased by Duke
Maximilian I of Bavaria from the
Katharinen church in Nuremberg
in 1613.

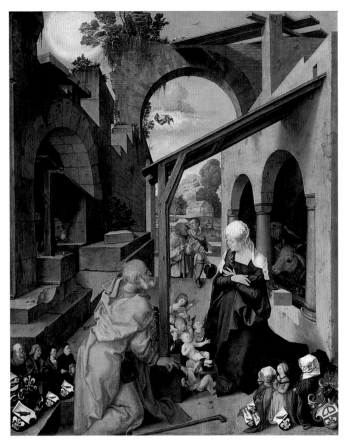

29

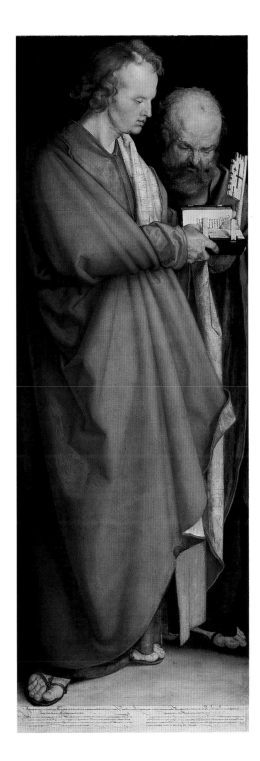 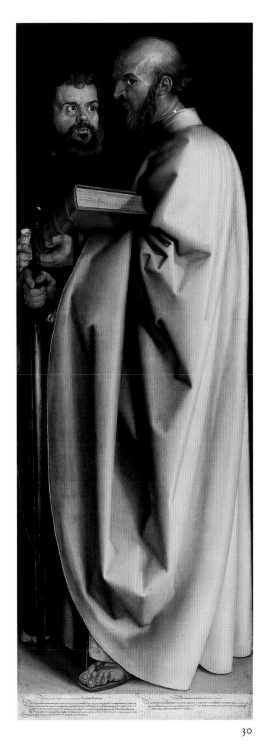

30

30
**Albrecht Dürer**
Nuremberg 1471–Nuremberg
1528
*The Four Apostles*
signed and dated 1526
Canvas
215 x 76 cm (each wing)
[545, 540]

On two wings are portrayed the
monumental robed figures of St
John the Evangelist and St Peter
(left), St Paul and St Mark (right).
Since Mark does not rank as an
apostle, the title recorded since
1538 — *The Four Apostles* — is
incorrect. The lower inscriptions,
by the hand of the Nuremberg

handwriting master Johannes
Neudörffer, decry false prophets
and sectarians. Bequeathed by
Dürer to the council of his native
town. Purchased by Elector
Maximilian I in 1627.

31
**Lucas Cranach the Elder**
Kronach 1472–Weimar 1553
*Christ on the Cross*
dated 1503
Pinewood
138 x 99 cm [1416]

The asymmetrical arrangement
of the crosses is striking, as they
fit, in a manner previously
unknown, into a landscape
reflecting the bitter anguish of
the figures. Provenance unknown.

32
**Matthias Grünewald**
Würzburg (?) *c.* 1475/80–
probably Halle 1528
*Saints Erasmus and Mauritius*
*c.* 1520/24
Limewood
226 x 176 cm [1044]

Part of the new furnishings
which Cardinal Albrecht of
Brandenburg commissioned for
his collegiate church in Halle.
The choice of theme was
influenced by the cult of
Erasmus, introduced by the
Cardinal, and the revival of the
veneration of St Mauritius in
Halle. Brought from the
collegiate church of St Peter and
Alexander in Aschaffenburg to
become the property of the
Bavarian state at the beginning of
the 19th century.

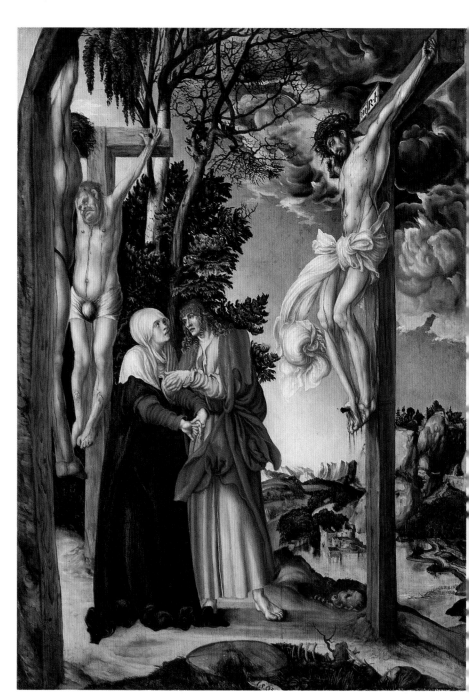

31

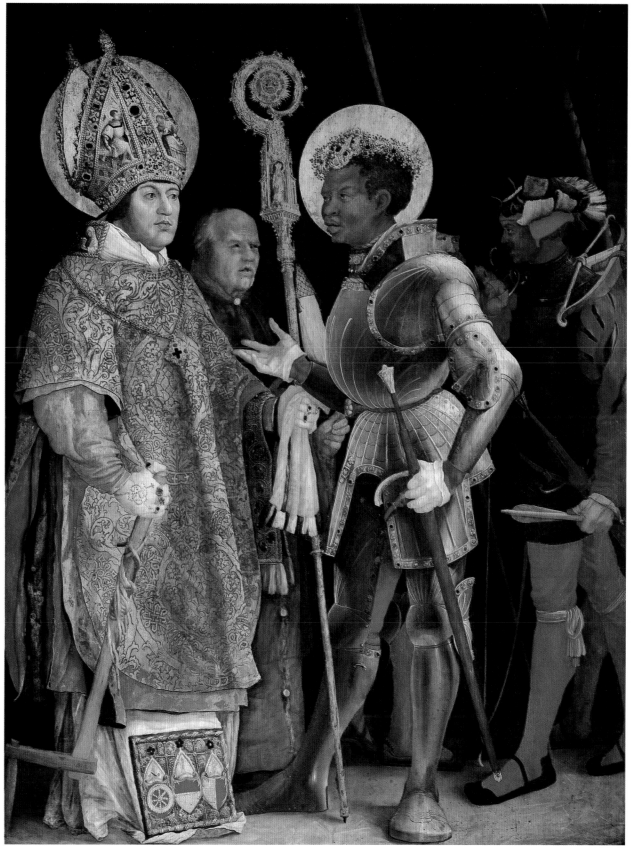

33

<table>
<tr><td>

33
**Albrecht Altdorfer**
presumably Regensburg c. 1480–
Regensburg 1538
*The Birth of the Virgin*
c. 1520
Pinewood
140.7 x 130 cm [5358]

An unusual choice of theme for a
church of this period. Quite
obviously connected with the
plans, proceeding at the same
time, of the Augsburg architect
Hans Hieber for the new
pilgrimage church of the 'Schöne
Maria' (Beautiful Mary). Found
its way from Salzburg (Schloss
Leopoldskron?) to become the
property of the Bavarian state in
1816.

</td><td>

34
**Lucas Cranach the Elder**
Kronach 1472–Weimar 1553
*Cardinal Albrecht von
Brandenburg before the Crucified
Christ*
c. 1520/30
Pinewood
158 x 112 cm [3819]

The position of the donor in front
and to the side of the crucified
Christ influenced the standard
pattern of the memorial portrait
right up to the 17th century.
Acquired from the collegiate
church in Aschaffenburg in
1829.

</td></tr>
</table>

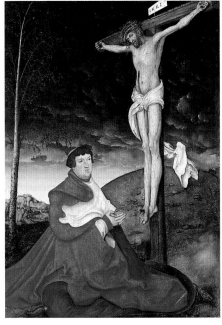

34

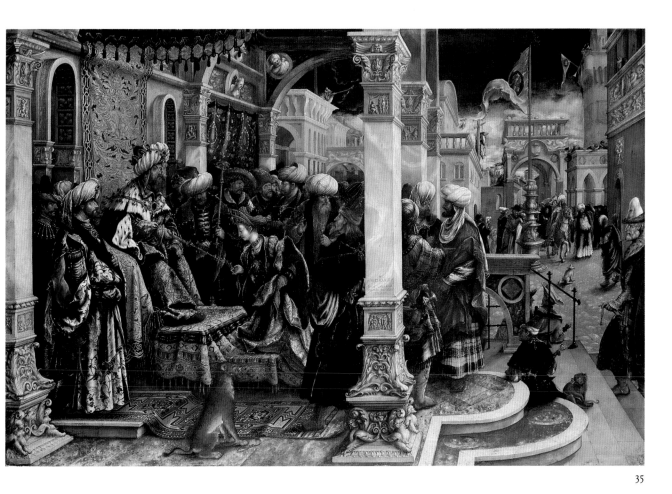

35

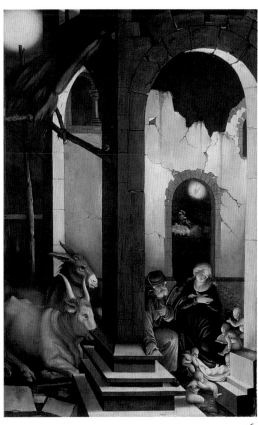

36

**35**
**Hans Burgkmair the Elder**
Augsburg 1473–Augsburg 1531
*The Story of Esther*
signed and dated 1528
Pinewood 103 x 156.3 cm [689]

Queen Esther intercedes with her
husband King Ahasuerus to save
the Jewish nation to which she
belongs. As a sign of mercy he
holds out the sceptre to the queen
(Book of Esther 2:5, 6, 7).
Renaissance forms, inspired
by Venice, create an impression
of oriental splendour. The panel
is part of a series — representing
great deeds of famous heroes and
heroines of ancient times, the
Old Testament and early Christ-
endom — commissioned by
Duke Wilhelm IV of Bavaria and
his wife Jacobea von Baden for a
room in the Residenz in Munich
(*cf* plate 38). From the Ducal
Kunstkammer in Munich.

**36**
**Hans Baldung** called **Grien**
Schwäbisch-Gmünd
1484/85–Strasbourg 1545
*The Nativity*
signed and dated 1520
Pinewood
105.5 x 70.4 cm [6280]

This Christmas picture is
illuminated by three sources of
light: from the Christ child as
the Light of the World, from the
Star of Bethlehem (top left) and
from the angel seen through the
archway, bringing the shepherds
the glad tidings. It was probably
once part of the decoration of the
'Neue Stift' (new collegiate church)
in Halle. Acquired from the
collegiate church in Aschaffenburg
in 1814.

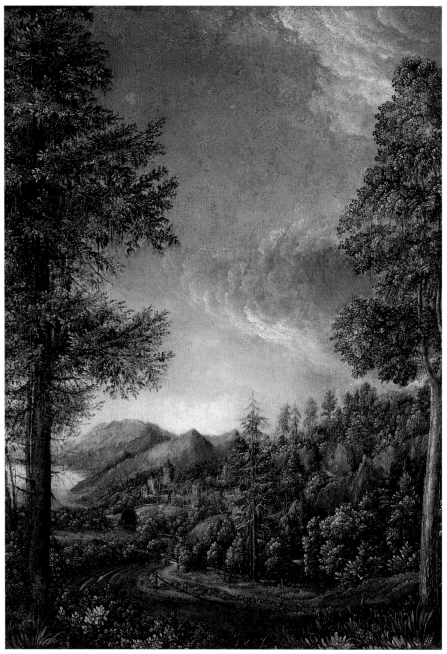

37

37
**Albrecht Altdorfer**
presumably Regensburg *c.* 1480–
Regensburg 1538
*Danube Landscape with Wörth
Castle near Regensburg*
probably shortly after 1520
Parchment on beechwood
30.5 x 22.2 cm [WAF 30]

This is the earliest landscape
painting whose topography can
be accurately ascertained. It is
concerned solely with the
reproduction of a particular
mood in a forest landscape.
Purchased by King Ludwig I in
1828 with the collection of the
Prince of Oettingen-Wallerstein,
into which the painting had
found its way with the Count
Josef von Rechberg collection
in 1815.

38
**Albrecht Altdorfer**
presumably Regensburg *c.* 1480–
Regensburg 1538
*The Battle of Issus (Alexander's
Battle)*
signed and dated 1529
Limewood
158.4 x 120.3 cm [688]

Alexander the Great conquers the
Persian King Darius III at Issus
in 333 BC. Using cartographical
material, the painter came to a
completely new, cosmic view of
landscape. The panel is part of
the series (*cf* plate 35) of great
heroic deeds commissioned by
Duke Wilhelm IV of Bavaria and
his wife Jacobea for a room in the
Residenz in Munich. Most of the
twenty or so pictures have been
kept in Munich, and a few in
Stockholm. From the Ducal
Kunstkammer in Munich.

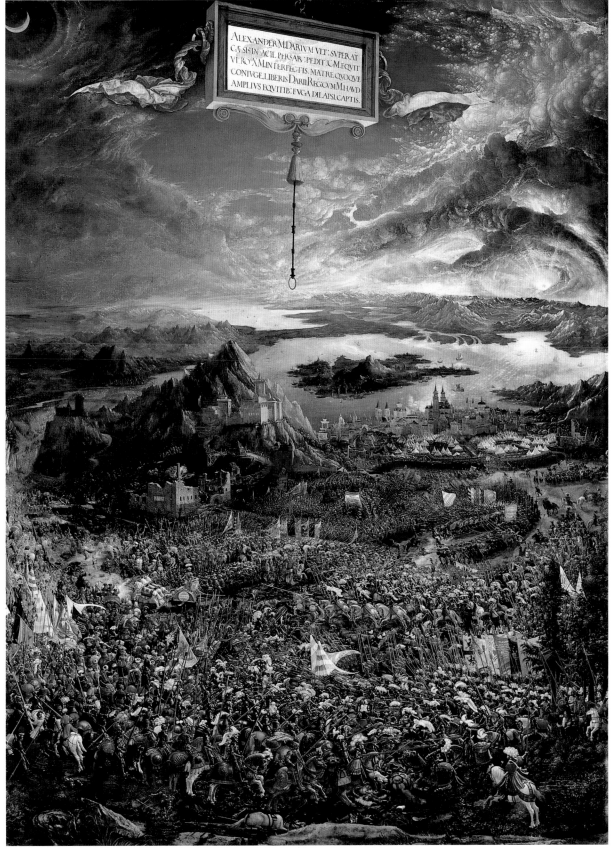

**39**
**Albrecht Altdorfer**
presumably Regensburg *c.* 1480–
Regensburg 1538
*Susanna and the Elders and the*
*Stoning of the Old Men*
signed and dated 1526
Limewood
74.8 x 61.2 cm [698]

This rather fairy-tale like picture
combines two episodes from the
Old Testament story of Susanna
(apocryphal passages related to
The Book of Daniel). From the
Ducal Kunstkammer in Munich.

**40**
**Hans Baldung** called **Grien**
Schwäbisch-Gmünd
1484/85–Strasbourg 1545
*Philip the Warlike, Count Palatine*
signed and dated 1517
Limewood
41.5 x 30.8 cm [683]

Count Philip (1503–48), younger
brother of Ottheinrich, Count
Palatine, was the son of
Ruprecht, Count Palatine of the
Rhine and Elisabeth, daughter of
Count Georg the Rich of Bavaria-
Landshut. Painted during the
young Count's Freiburg period
(1516–19), when he was studying
humanities and law at the
university. From Neuburg Castle
on the Danube.

39

40

**41**
**Albrecht Altdorfer**, detail of
*Susanna and the Elders and the*
*Stoning of the Old Men* (plate 39)

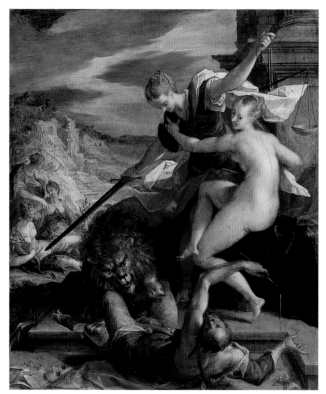

42

43

44

45

**42**
**Hans von Aachen**
Cologne 1552–Prague 1615
*The Victory of Tru.*
signed and dated 159?
Copper
56 x 47 cm [1611]

Justice (with the scales) is
defending the naked Truth against
Falsehood, stretched out on the
ground. The picture was probably
a gift from Emperor Rudolf II to
the Bavarian Elector Maximilian I.
From the Elector's gallery.

**43**
**Peter Candid (Pieter de Witte)**
Bruges *c.* 1548–Munich 1628
*Duchess Magdalena of Bavaria*
probably 1613
Pinewood
97.5 x 71.5 cm [2471]

Magdalena (1587–1628), daugher
of Duke Wilhelm V of Bavaria,
married Duke Wolfgang Wilhelm
von Pfalz-Neuburg in 1613. From
Schleissheim Palace.

**44**
**Johann Rottenhammer**
Munich 1564–Augsburg 1625
*Diana and Actaeon*
signed and dated 1602
Copper
34 x 48 cm [1588]

After secretly watching Diana
and her nymphs bathing,
Actaeon is punished by the
goddess who turns him into a
stag, which is then torn apart by
Actaeon's own hounds. A
transformation theme,
particularly popular with
mannerist artists, from Ovid's
*Metamorphoses*. From the
Elector's gallery.

**45**
**Johann Liss**
Oldenburger Land *c.* 1597–
Venice 1629/30
*The Death of Cleopatra*
*c.* 1622/24
Canvas
97.5 x 85.5 cm [13434]

The Egyptian Queen Cleopatra
committed suicide by means of
a poisonous snakebite which,
according to Egyptian belief,
conferred immortality upon her.
Flemish influence, and also that
of Caravaggio, are clearly visible
in the sensuously flowing style of
painting and buxom fleshiness.
Purchased from Swiss art dealers
in 1964.

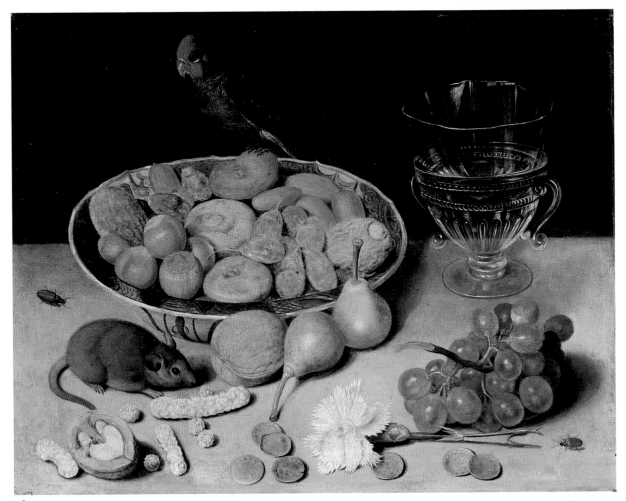

46

46
**Georg Flegel**
Olmütz (Moravia)
1566–Frankfurt 1638
*Still Life*
early 17th century
Panel
22 x 28 cm  [5026]

The rather casual arrangement
of the objects against a raised
horizon points to an early work
of the painter. From the
monastery of Raitenhaslach.

47

47
**Adam Elsheimer**
Frankfurt 1578–Rome 1610
*Flight into Egypt*
signed and dated 1609
Copper
31 x 41 cm [216]

It has been thought by some that this picture gives an anticipatory hint of the Romantics' capacity to be thrilled by a walk through a soul-stirring night landscape. From the Düsseldorf gallery.

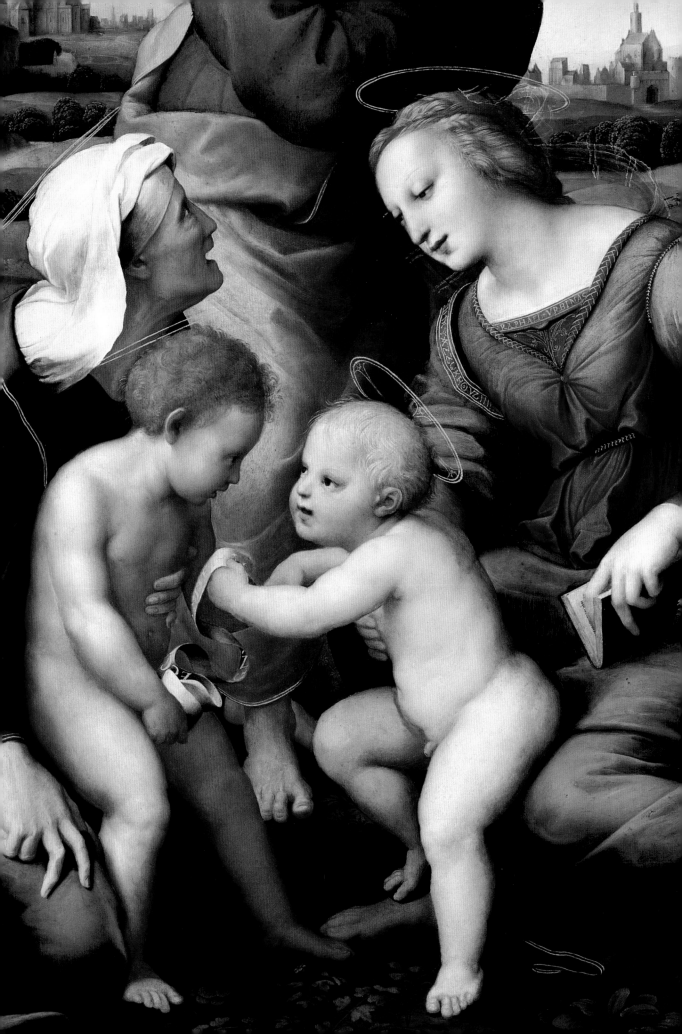

# Italian Painting

It is the excellence of the paintings in the Italian collection of the Alte Pinakothek, rather than their great number, that gives it its special distinction. This becomes particularly evident when one considers the prestigious stocks of Italian panel paintings of the fourteenth and fifteenth centuries which have come down to us as a result of Ludwig I's passion for collecting. Apart from the king's own artistic sensitivity, it was above all romantic ideas emanating from the religious and historical artistic sources, coupled with the striving for a renewal of the Christian faith, that guided him in his selection of these particular pictures. It is true that Ludwig was supported in his manifold endeavours by experienced advisers such as Johann Georg von Dillis (1749–1841) and Martin von Wagner (1777–1858), but the essential qualities for the success of the whole enterprise were ultimately provided by the never-flagging initiative and the astonishingly catholic taste of the king himself. The basic character of the collection of early Italian panel paintings built up at that time has not been radically changed even by later acquisitions. This has held good even in the face of such important additions as the Leonardo *Virgin and Child* (plate 57), purchased in 1899 from the Wetzlar dispensary in Günzburg, or the *Lamentation* by Liberale da Verona, acquired from Florentine dealers in 1890. Even Luca Signorelli's tondo of the Madonna, also acquired in Florence in 1894, and the *Virgin of the Annunciation* by Antonello da Messina (plate 56) only serve to underline the coherence of this collection of exquisite works of art.

A true impression of the size of the collection can only be gained, however, when one takes into account the number of paintings which have had to be relegated to the store-room for various reasons. This is mainly because of the lack of space caused by today's more spacious style of hanging, but another contributory factor has been the attempt to incorporate into the collection works of art from periods which had long been denied the attention they deserved.

On the other hand, the stocks of Venetian paintings of the sixteenth century, which have been in the Alte Pinakothek since its inception, have retained their original prominence. Among them are such important master-pieces as *Christ Crowned with Thorns* by Titian (plate 73) and Tintoretto's extensive *Gonzaga* cycle (plate 70).

Ultimately, Ludwig's particular predilections worked to the detriment of the seventeenth- and eighteenth-century Italian schools as regards the amount of space they were allotted in the Alte Pinakothek. Because of the somewhat invidious position Baroque painting had fallen into in his time, vis-à-vis the classicism of the High Renaissance, only a relatively limited number of examples found their way into the Alte Pinakothek. The gallery's display scheme had already been designed, even down to structural details, making further additions difficult. At

**Raphael (Raffaello Santi)**, detail of *Holy Family from the Canigiani House* (plate 60)

all events, the selection made at that time is completely disproportionate to the number of paintings of this period which were actually available — having found their way first into the Munich Hofgarten gallery around the turn of the nineteenth century, principally from Schleissheim, Düsseldorf and Mannheim. Eventually it was possible to clear only one of the main rooms of the Alte Pinakothek to accommodate them, along with a series of side galleries.

The eighteenth century, which by its very nature was the most immediately exposed to the adverse criticism of classicism, was almost completely passed over at the time the Alte Pinakothek was being furnished. The only exceptions were Giovanni Battista Tiepolo's *Adoration of the Kings* (plate 78) — painted between 1751 and 1753 for the monastery of Schwarzach in Franconia and transferred to Munich as early as 1804 in the course of the secularization taking place at the time — and a series of *vedute*, originally comprising four paintings, by Antonio Canaletto. The systematic planning of additions in this area began only in the twentieth century and, as on so many other occasions, the initiative was taken by Hugo von Tschudi when he purchased Francesco Guardi's *Venetian Gala Concert* (plate 81) in 1909. Enduring interest in this artist was stimulated by the patronage of the Bayrische Hypotheken-und Wechselbank (today HypoVereinsbank), which meant that the bank's collection of eighteenth-century masterpieces already on loan to the gallery could be enlarged by the purchase of additional paintings by Guardi, along with works by Pietro Longhi, Giovanni Battista Battoni, Rosalba Carriera, Alessandro Magnasco and Michele Marieschi.

This impressive group was agreeably rounded off by Francesco Guardi's view of Santa Maria della Salute, which was placed at the disposal of the gallery by the Association for the Promotion of the Alte Pinakothek (Verein zur Förderung der Alten Pinakothek).

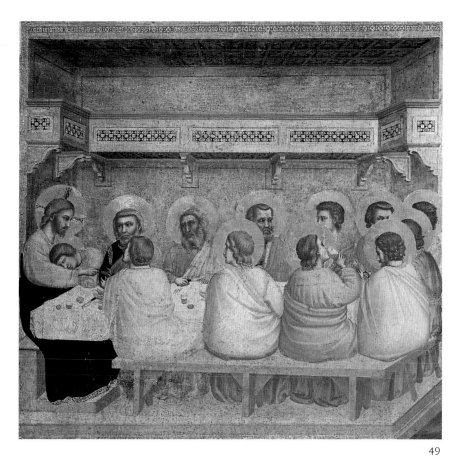

49

49
**Giotto di Bondone**
Colle de Bondone, near Florence
1266–Florence 1337
*The Last Supper*
probably soon after 1306
Chestnut
42.5 x 43.2 cm  [643]

The sober composition, dispensing
with all ornamental details, in
which the plastically rounded
figures are arranged parallel to
the picture in a narrow box-room,
reveals Giotto as a fresco painter
accustomed to the monumental
format. The picture is one of a
series of seven panels, two others
of which are preserved in the Alte
Pinakothek. Sent as a present to
Crown Prince Ludwig in 1805;
the two other panels were
purchased from Count Lucchesi
by King Maximilian I in 1813.

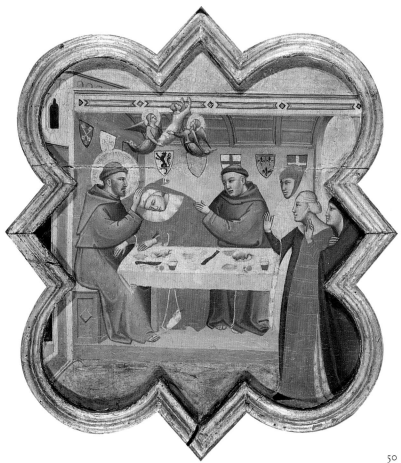

50

50
**Taddeo Gaddi**
Florence *c.* 1300–Florence 1366
*The Death of the Nobleman of
Celano*
*c.* 1340
Poplar, gold ground; in original
quatrefoil frame
34.8 x 30.7 cm  [10676]

The companion panel, *St Francis
Offering the Sultan Ordeal by Fire*,
is also in the Alte Pinakothek.
Together with twenty-four other
pictures (twenty-two in Florence,
Galleria dell' Accademia; two in
Berlin, Staatliche Museen), they
originally formed the panels of
the doors of a sacristy cupboard
in Santa Croce in Florence. The
inner panels showed scenes from
the life of Christ, the outer ones
pictures from the life of St Francis
(according to Bonaventura's *Vita*).
Acquired 1940.

51
**Sienese Master**
working *c.* 1340
*The Ascension of the Virgin*
*c.* 1340
Poplar, gold ground
72.5 x 32.5 cm  [WAF 671]

In the upper part, the Coronation
of the Virgin is represented on a
smaller scale. The finely stamped
gilded background lends the
hieratic composition an aura which
is independent of space and time.
Purchased by Crown Prince
Ludwig in 1825.

52

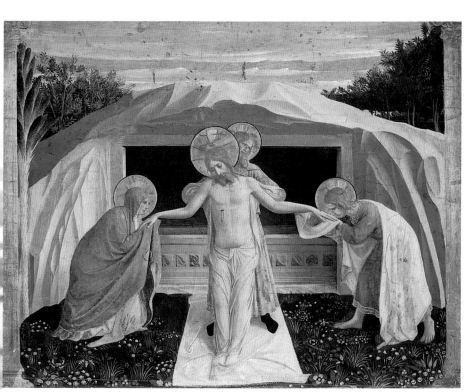

53

**52**
**Masolino (Tommaso di Cristoforo Fini)**
Panicale di Valdarno
*c.* 1383–before 1447
*Virgin and Child*
*c.* 1435/40
Chestnut, gold ground
95.5 x 57 cm  [WAF 264]

Antique type of 'Madonna dell' Umiltà', the humble mother of God. The very pronounced corporeality of the figures, particularly of the child, reveals the influence of Masaccio, although the picture in general is still beholden to the international 'Soft Style'. Acquired by King Ludwig I later than 1826.

**53**
**Fra Angelico**
Vicchio near Mugello
*c.* 1395/1400–Rome 1455
*The Entombment of Christ*
Poplar wood
38 x 46.5 cm  [WAF 38a]

In an almost symmetrical composition, the picture shows the dead Christ before the tomb, supported by Nicodemus and lamented by Mary and John. Through the subtlest of artistic means, the picture is raised beyond any temporal sphere and invested with symbolic significance. The painting originally formed the central panel of the predella on the high altar in the church of San Marco, Florence. The altarpiece came into being in 1438–40 as a gift of the Medici family. Other parts of the predella are held in the Alte Pinakothek (WAF 36, 37, 38), and in Dublin, Florence, and Paris. The main panel of the altarpiece has remained in the church of San Marco. Acquired by Crown Prince Ludwig 1813.

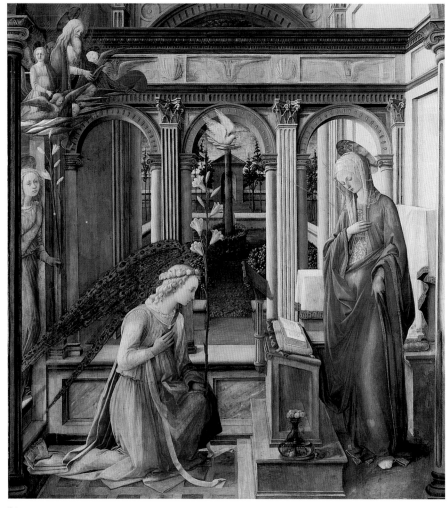

54

55

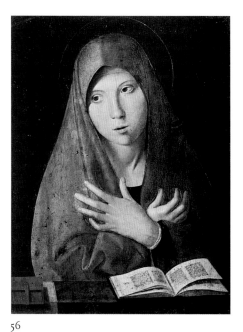

56

54
**Fra Filippo Lippi**
Florence *c.* 1406–Spoleto 1469
*The Annunciation*
*c.* 1450
Poplar
203 x 186 cm [1072]

This scene, framed by early Renaissance architecture in delicate colours, is reminiscent of the medieval *hortus conclusus* as an allusion to the immaculate purity of the mother of God. The altar picture came from the monastery church of the Suore Murate (an enclosed order of nuns in Florence), and was purchased for the royal collection in Munich at the beginning of the 19th century.

55
**Fra Filippo Lippi**
Florence *c.* 1406–Spoleto 1469
*Virgin and Child*
*c.* 1465
Chestnut
76.3 x 54.2 cm [647]

In his late works the painter has gone beyond the bright local colour of his early period. The forward-looking conception of landscape is particularly noteworthy. Purchased for Crown Prince Ludwig from the Abbiate Rivanni in Florence in 1808.

56
**Antonello da Messina**
Messina *c.* 1430–Messina 1479
*Virgin of the Annunciation*
*c.* 1473/74
Walnut
42.5 x 32.8 cm [8054]

Probably from a diptych, the other half of which would have shown the angel of the annunciation. The Early Netherlandish models are unmistakable. Purchased from art dealers in Munich in 1897.

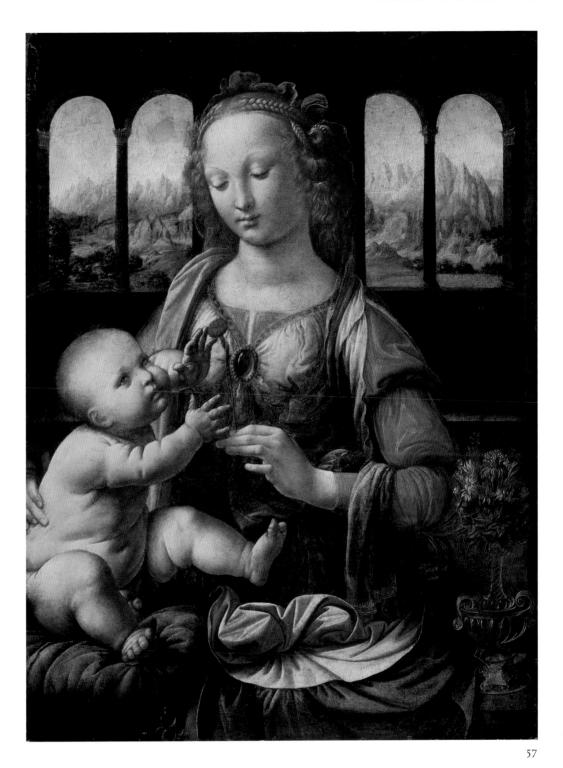

57

57
**Leonardo da Vinci**
Villa Anchiana, near Vinci
(Empoli) 1452–Château de Cloux,
near Amboise, 1519
*Virgin and Child*
*c.* 1473
Poplar
62 x 47.5 cm [7779]

Leonardo's famous *sfumato*
triumphed over the bright local
colour of Quattrocento painting.
The composition is no longer the
sum of its individual parts but
the reflection of a new, total
world-view. Purchased from
Dr A. Haug in Günzburg in

1899, after Adolph Bayersdorfer
had recognized the hand of
Leonardo in a previously
unknown work.

58
**Domenico Ghirlandaio**
Florence 1449–Florence 1494
*The High Altar of Santa Maria
Novella in Florence*
*c.* 1494
Poplar
221 x 198 cm (central panel)
[1078]

The altarpiece, donated by
Giovanni Tornabuoni, was not
quite completed at the time of the
painter's death. The central panel,
composed on strictly architectonic
lines, shows Mary with the Child
and Saints Dominic, Michael,
John the Baptist and John the
Evangelist, while the side panels
(also in the Alte Pinakothek) show
St Catharine of Siena and St
Laurence. After the altar was
dismantled in 1804, Crown Prince
Ludwig purchased the panels
from the Medici family in
Florence in 1816. Other parts of
the altarpiece are to be found in
the museum in Budapest and on
the art market.

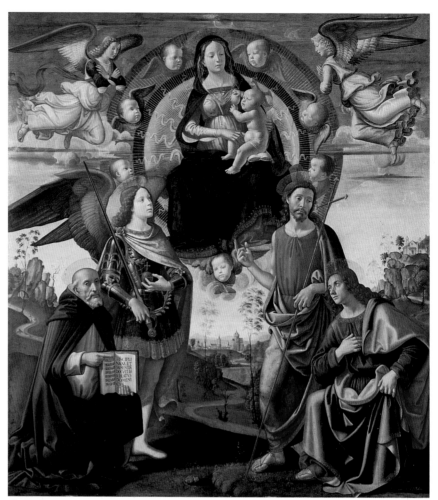

58

59

59
**Pietro Perugino**
Città della Pieve (Umbria)
1445–Fontignano (Peruia) 1523
*The Vision of St Bernard*
*c.* 1490/94
Chestnut
173 x 170 cm [WAF 764]

Legend has it that the Virgin,
accompanied by angels, appeared
to St Bernard of Clairvaux.
Behind him are John the
Evangelist and the apostle
Bartholomew. This altarpiece can
be regarded as one of Perugino's
major works. It was executed for
the chapel of the Nasi family in
Santa Maria Maddalena dei Pazzi
in Florence. Purchased by King
Ludwig I from the Capponi house
in Florence in 1829/30.

60
**Raphael (Raffaello Santi)**
Urbino 1483–Rome 1520
*Holy Family from the Canigiani
House*
*c.* 1505/6
Lime wood
131 x 107 cm [476]

This picture, painted by Raphael
for Domenico Canigiani at the
beginning of the Florentine period,
invites comparison, above all in
the presentation of the figures,
with Fra Bartolomeo and Leonardo.
The putti, painted over in the late
18th century, were restored in
1983. The painting came into the
Düsseldorf gallery as a gift from
Archduke Cosimo III of Tuscany
to his son-in-law, Elector Johann
Wilhelm of the Palatinate.

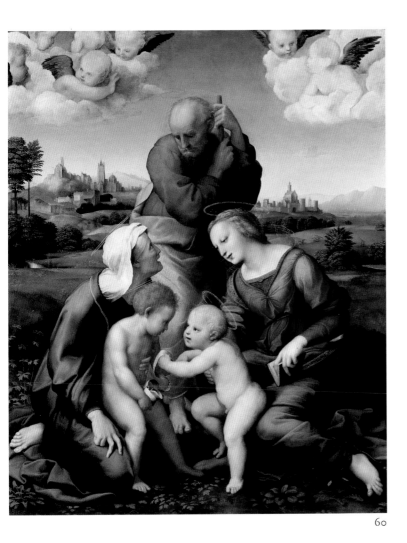

60

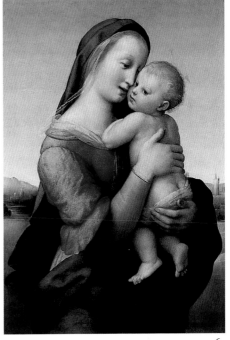

61

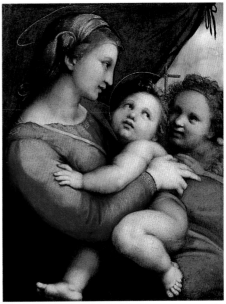

62

61
**Raphael (Raffaello Santi)**
Urbino 1483– Rome 1520
*The Tempi Madonna*
*c.* 1507
Chestnut
75 x 51 cm [WAF 796]

This picture — one of the major
works of the Florentine period
— came from the Tempi house
in Florence and was finally
purchased by King Ludwig I in
1809 after many years of effort.

62
**Raphael (Raffaello Santi)**
Urbino 1483–Rome 1520
*Madonna della Tenda (with
the Curtain)*
*c.* 1513/14
Chestnut
65.8 x 51.2 cm [WAF 797]

The mature style of the figures,
which almost fill the area of the
picture, invites comparison with
Michelangelo's Sistine Chapel
ceiling. The picture, which is
recorded as being in the Escorial
from the 17th century until 1809,
found its way to England during
the Napoleonic wars and it was
there acquired by Crown Prince
Ludwig in 1819.

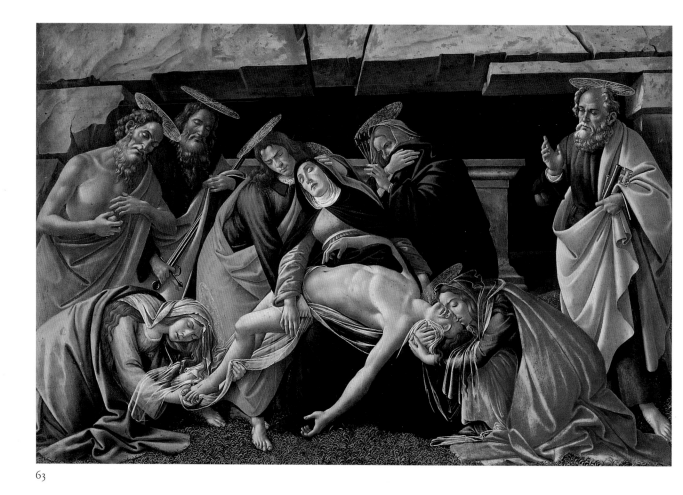

63

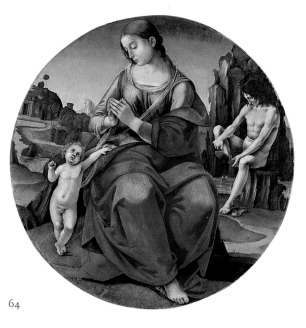

64

**63**
**Sandro Botticelli**
Florence *c.* 1445–Florence 1510
*Lamentation*
after 1490
Poplar
140 x 207 cm  [1075]

The austere, ascetic manner of
expression reflects the enduring
impression made on the painter
by Savanorola's sermons on
repentance. The picture comes
from the Paolino monastery in
Florence and was acquired by
Crown Prince Ludwig in 1814.

**64**
**Luca Signorelli**
Cortona *c.* 1445/50–Cortona 1523
*Virgin and Child*
*c.* 1495
Limewood
diam. 87 cm  [7931]

The tondo was particularly
popular in the Florentine
Renaissance. The motif of the
classical 'Boy with a Thorn'
appearing in the background
was taken as a possible allusion
to the life of unredeemed man
in his natural state. Acquired
from the Ginori Palace in Florence
in 1894.

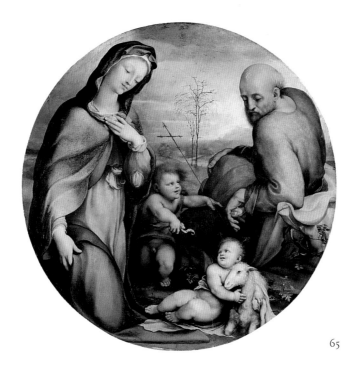

65

**Domenico Beccafumi
(Domenico Mecuccio or
Domenico Mecarino)**
near Siena 1486–Siena 1551
*Holy Family with the Young
St John*
c. 1515
Chestnut
diam. 113 cm [1073]

Acquired by Crown Prince Ludwig
in Siena in 1816.

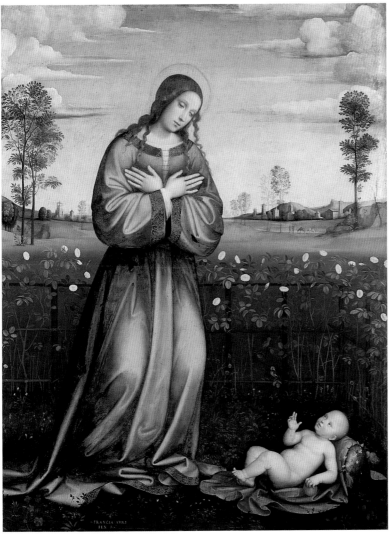

66

**Francesco Francia (Francesco
Raibolini)**
Bologna *c.* 1450–Bologna 1517
*Madonna in the Rose Bower*
signed, immediately after 1500
Poplar
174.5 x 131.5 cm [994]

From the late Middle Ages
onwards, the rose bower was
regularly used to symbolize the
virtues of the Virgin, drawing on
the language of flowers. This
devotional picture, painted for
the Capuchin church in Modena,
found its way by devious paths
into the collection of the Empress
Josephine in Malmaison, from
whom it was purchased by
Crown Prince Ludwig in 1815.

**67**
**Jacopo de' Barbari**
Venice *c.* 1440–the Netherlands
before 1515
*Still Life with Partridge, Gloves
and Cross-bow Arrow*
signed and dated 1504
Limewood
52 x 42.5 cm [5066]

According to the inventories
of art objects which have come
down to us, we are dealing here
— if this was in fact painted as
a picture in its own right —
with the oldest extant still life
in European panel painting.
A short time later Dürer and
Cranach the Elder painted still
life watercolours. Recorded as
being in Neuburg Castle on the
Danube from 1764 onwards.
Transferred to Schleissheim
Palace in 1804.

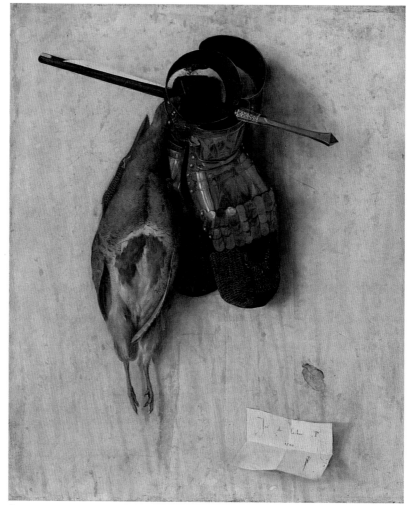

67

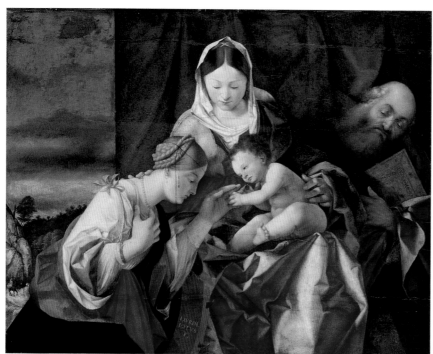

68

**68**
**Lorenzo Lotto**
Venice c. 1480–Loreto 1556
*The Mystical Marriage of
St Catherine*
signed, 1505/8
Panel
71.3 x 91.2 cm [32]

After Catherine, daughter of King
Costus of Cyprus, converted to
Christianity by baptism, she had
a dream in which the Virgin
appeared with the infant Christ,
who married her. Transferred
from the Prince Bishop's
residence in Würzburg to
Munich in 1804.

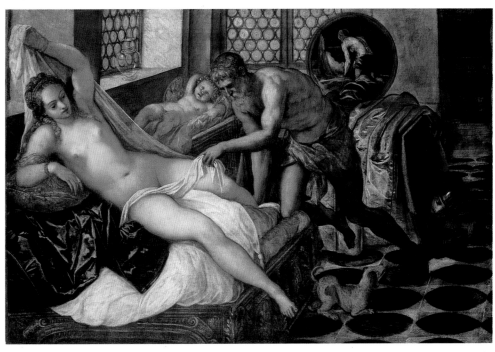

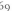

69

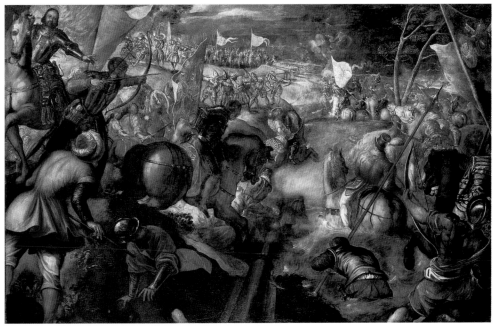

70

69
**Tintoretto (Jacopo Robusti)**
Venice 1518–Venice 1594
*Venus and Mars Surprised by Vulcan*
*c.* 1555
Canvas
135 x 198 cm  [9257]

The adulterers Venus and Mars are found guilty and subsequently suffer the derision of the gods (8th Song of the *Odyssey*). Probably from the Earl of Arundel's collection, from which it found its way into the possession of the Duke of Devonshire. Purchased from F. A. Kaulbach, Munich, in 1925.

70
**Tintoretto (Jacopo Robusti)**
Venice 1518–Venice 1594
*Francesco II Gonzaga Fighting in the Battle against Charles VIII of France on the River Taro* (1495), completed 1579
Canvas
268.5 x 422.5 cm  [7309]

Probably acquired by Elector Max Emanuel. Evidence of its presence in Schleissheim from 1748. From a series of eight history paintings commissioned by Duke Guglielmo, the Earl of Gonzaga, for the Palazzo Ducale in Mantua. Stylistically similar to the contemporaneous paintings for the Scuola di San Rocco in Venice.

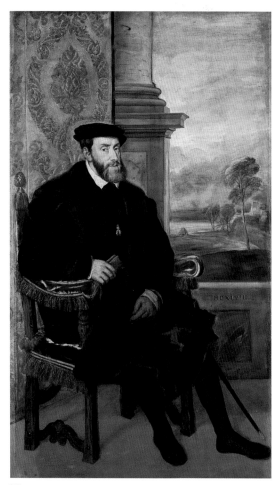

71

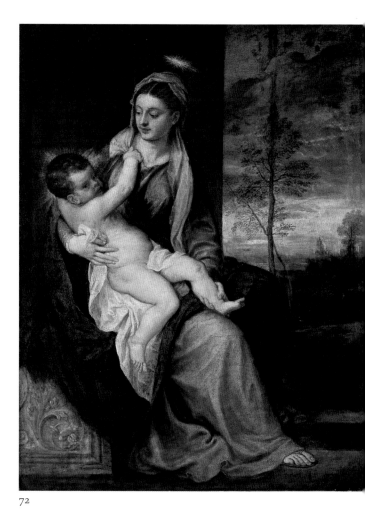

72

**71**
**Titian (Tiziano Vecellio)**
Pieve di Cadore *c.* 1487/90–
Venice 1576
*Emperor Karl V*
signed and dated 1548
Canvas
203.5 x 122 cm [632]

Commissioned by the Emperor
and executed during Titian's stay
in Augsburg in 1548. Whereas
the Madrid equestrian portrait
completed at the same time
represents the Emperor in
armour as the victor of the Battle
of Mühlberg, this portrait brings
out the human features of the
ageing ruler afflicted by gout.
From the Elector's gallery in
Munich.

**72**
**Titian (Tiziano Vecellio)**
Pieve di Cadore *c.* 1487/90–
Venice 1576
*Virgin and Child in Evening
Landscape*
*c.* 1560
Canvas
173.5 x 132.7 cm [464]

Titian's late style reveals itself
in the richly graded palette of
substantially applied colours.
Probably in the possession of
Philip II of Spain, recorded as
being in the Escorial in 1606.
Taken from there by Joseph
Bonaparte in 1809 and given by
him to General Sebastiani, from
whom it was purchased for King
Maximilian I by J. G. Dillis in 1814.

**73**
**Titian (Tiziano Vecellio)**
Pieve di Cadore *c.* 1487/90–
Venice 1576
*Christ Crowned with Thorns*
late work
Canvas
280 x 182 cm [2272]

Developed entirely from the use
of colour — there is virtually no
drawing — this picture can be
regarded as the epitome of Titian's
rich life's work. Along with
Dürer's *Four Apostles*, which also
constitutes both a human and an
artistic testament, it is no doubt
one of the most unforgettable
masterpieces in the Alte
Pinakothek.

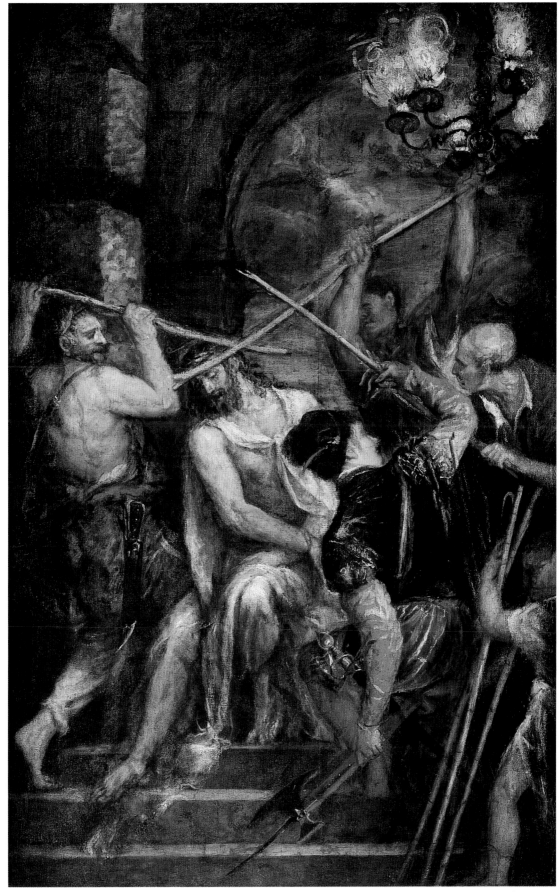

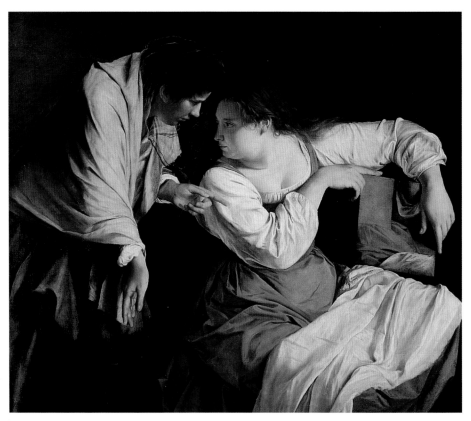

74

74
**Orazio Gentileschi**
Pisa 1577–Rome 1653
*Martha Reproving Her Sister Mary*
c. 1620
Canvas
133 x 155 cm  [12726]

The interpretation of this picture, composed sympathetically and with powerful plasticity to illustrate Luke 10:38–42, is still in doubt. It is probably intended to convey the admonishing of Vanity (with the mirror) by Virtue (in simple, loose clothing). The gift of Georg and Otto Schäfer, Schweinfurt, for the reopening of the Alte Pinakothek in 1957.

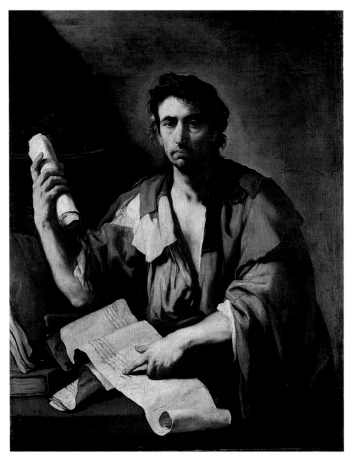

75

75
**Luca Giordano**
Naples 1634–Naples 1705
*A Cynical Philosopher*
c. 1660
Canvas
131 x 103 cm  [492]

A companion piece is also in the Alte Pinakothek. The realistic conception of portrait painting was the result of coming to grips with the Caravaggesque style of Ribera. The Greek philosophical school of the Cynics stood for a frugal life-style. From the Düsseldorf gallery.

76
**Guido Reni**
Calvenzano, near Bologna
1575–Bologna 1642
*The Assumption of the Virgin*
1631/42
Silk
295 x 208 cm [446]

Formerly the high altar of the
church of the Confraternity of
Santa Maria degli Angioli di
Spilamberto (Modena). A typical
example of Bolognese baroque
painting in classicistic mood,
contrasting markedly with the
*verismo* of the Caravaggists. From
the Düsseldorf gallery.

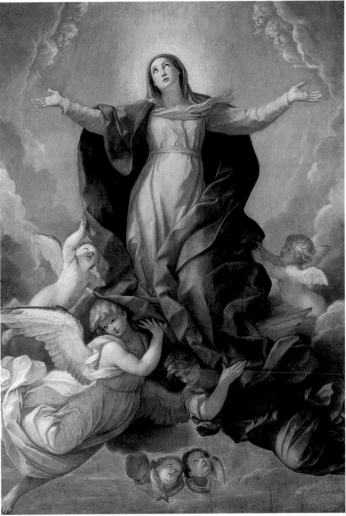

76

77
**Bernardo Cavallino**
Naples 1615–Naples 1656
*Erminia among the Shepherds*
c. 1650/55
Canvas
diam. 50.2 cm [960]

Companion picture to *Erminia
and the Wounded Tancred*, also in
the Alte Pinakothek. The theme
is from Tasso's *Gerusalemme
Liberata* (VII: 6–7). From the
Mannheim gallery.

77

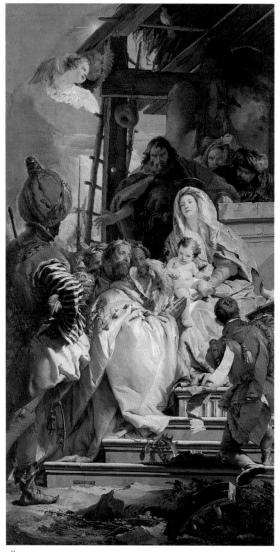

78

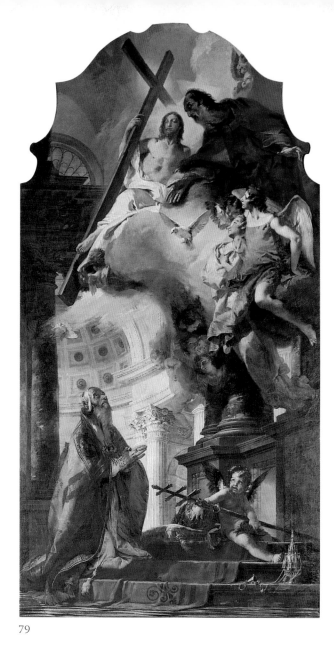

79

**78**
**Giovanni Battista Tiepolo**
Venice 1695–Madrid 1770
*The Adoration of the Magi*
signed and dated 1753
Canvas
408 x 210.5 cm [1159]

Altarpiece for the monastery
of Schwarzach (Lower
Franconia). This great festive
composition goes right back,
via Sebastiano Ricci, to
Veronese. Acquired from the
monastery of Schwarzach in
1804 when its property was
dispersed.

**79**
**Giovanni Battista Tiepolo**
Venice 1695–Madrid 1770
*Pope Clemens Worshipping
the Trinity*
c. 1739
Canvas
488 x 256 cm [877]

Commissioned by Elector
Clemens August of Cologne
and executed for the
Chorfrauen church of
Nymphenburg Palace
(destroyed in 1943). The
donor identifies himself with
his saintly namesake in this
'theatrical' composition.
Received on loan from the
Chorfrauen church in 1938.

80
**Giovanni Battista Tiepolo**,
detail of *The Adoration of
the Magi* (plate 78)

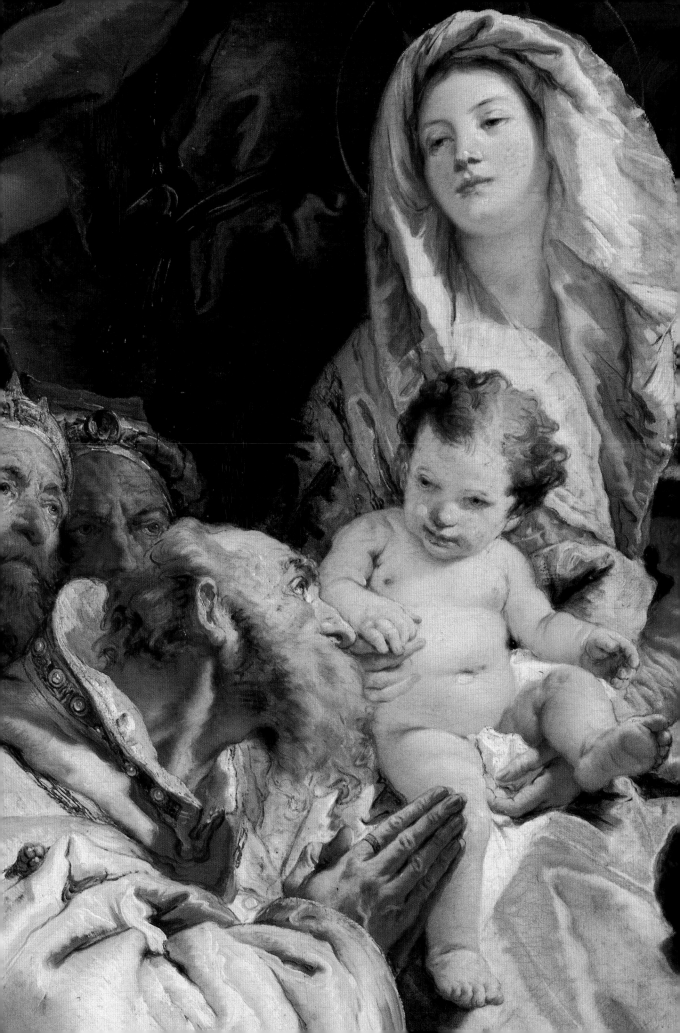

81
**Francesco Guardi**
Venice 1712–Venice 1793
*Venetian Gala Concert*
*c.* 1782
Canvas
67.7 x 90.5 cm [8574]

Part of a cycle commissioned by
the senate on the occasion of the
visit of the Russian Grand Duke
Paul Petrovitch and his wife
Maria Feodorovna in 1782. It
depicts the ladies' concert in the
Scala dei Filarmonici under the
auspices of the old procurators.
Seldom in art history have tones
of colour and sound been so
felicitously mingled. Purchased
from English art dealers (the
Tschudi-Donation).

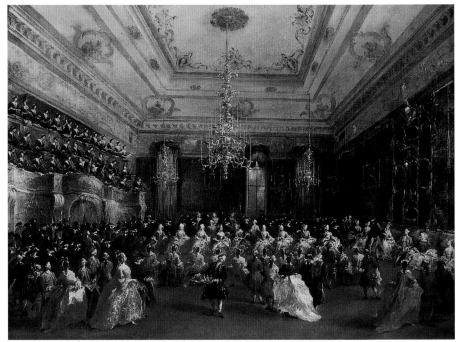

81

82
**Michele Marieschi**
Venice 1710–Venice 1744
*View of the Piazzetta dei Leoni*
*c.* 1740
Canvas
54.5 x 83.6 cm [14788]

A companion piece, *The Grand
Canal near the Ca' Pesaro*, is also
in the Alte Pinakothek. The
artist's strangely 'naïve' views of
Venice fall between the *vedute* of
Canaletto and Guardi. Purchased
from London art-dealers in 1983.

83
**Francesco Guardi**
Venice 1712–Venice 1793
*Regatta on the Canale della
Giudecca*
*c.* 1784/89
Canvas
61 x 93 cm [HUW 34]

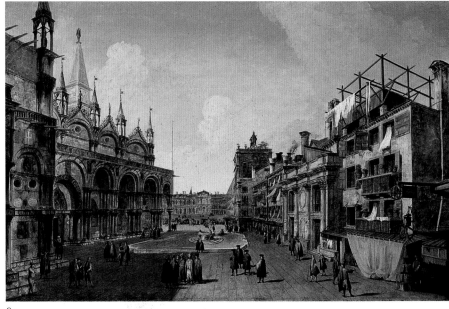

82

This companion piece to the
*Bacino di San Marco* (in the Emil
Böhrle collection, Zürich) has the
effect of a wide-angle photograph.
The artist was more concerned
with the sparkling depiction of
a grand panorama than topo-
graphical accuracy. Purchased
from London art dealers in 1975
for the collection of the Bayrische
Hypotheken- und Wechselbank
in the Alte Pinakothek.

84
**Canaletto (Antonio Canal)**
Venice 1697–Venice 1768
*Piazzetta and Bacino di
San Marco in Venice*
*c.* 1730/40
Canvas
69.1 x 94.5 cm

Companion piece to *Santa Maria
della Salute*, also in the Alte
Pinakothek. These cool, sober
*vedute* were purchased by King
Ludwig I from the estate of the
sculptor Antonio Canova along
with two other companion
pictures (now in the H. J. Joel
collection, London).

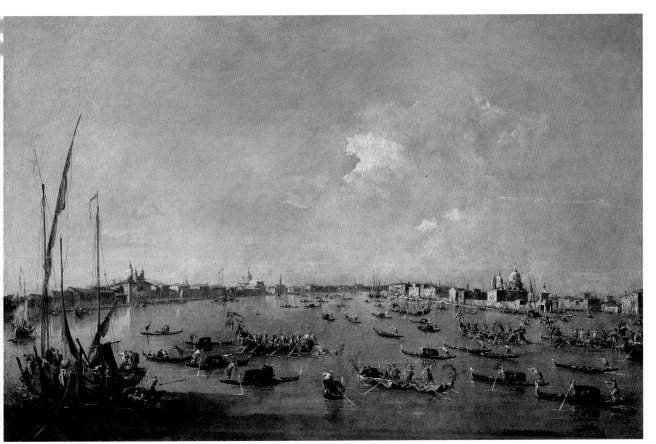

83

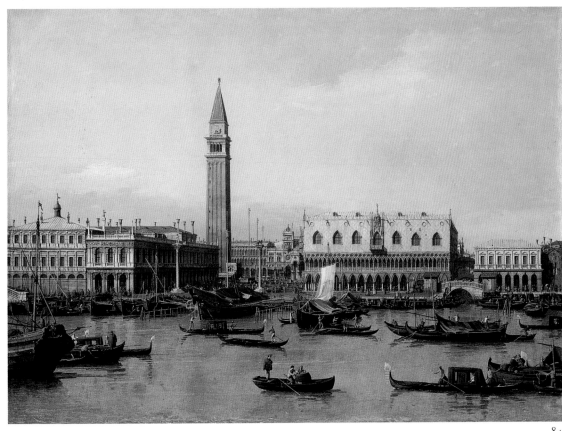

84

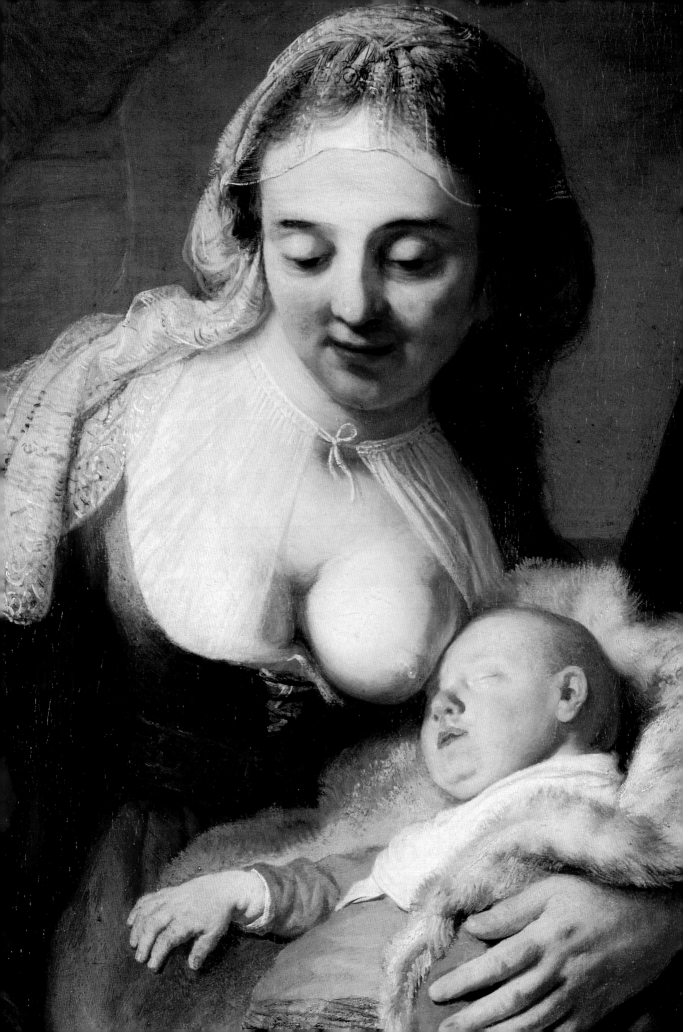

# Dutch Painting

In 1609 seven Protestant provinces of the northern Netherlands broke free of Spanish rule, leaving only the Catholic provinces in the south under Spanish suzerainty. The peak of seventeenth-century Dutch painting was reached during a period of political and economic advancement, which occurred immediately after the northern 'Dutch' provinces, acquiring political independence and religious freedom, founded a republic. The high status of this art was achieved due to the discovery of the everyday world of domestic interiors and immediate surroundings. With total holdings of some 1200 paintings, the Bayerische Staatsgemäldesammlungen owns one of the most extensive collections of Dutch art in the world. It made its way to Munich at the turn of the nineteenth century, as a result of succession arrangements relating to several lines of Wittelsbachs.

The most important Dutch paintings to be seen in the Alte Pinakothek today come from the Düsseldorf gallery of Elector Johann Wilhelm of the Palatinate. These are from Rembrandt's Passion cycle, which was painted between 1633 and 1639 at the behest of Frederik Hendrik, Stadholder of the Netherlands.

Elector Johann Wilhelm, however, was not only a discriminating collector but also an outstanding patron. Like other great art lovers of the time, he was fond of Dutch and decorative still life painting. So, along with Italian artists, it was mainly Dutch painters that he engaged at his court. These included Adriaen van der Werff, who was appointed court painter to the Elector in 1696 and raised to noble rank in 1703. Van der Werff was one of the most celebrated artists of his time, overwhelmed with commissions from the royal courts of Europe. The painting *Children Playing in front of a Statue of Hercules* (plate 114), executed whilst he was still in Holland, was the first to be acquired by the Elector. Jan Weenix also carried out extensive commissions for Johann Wilhelm, such as a series of animal still lifes painted for the prince's hunting lodge at Bensberg, which were greatly admired and enthusiastically described by Goethe, who saw them while on a journey through the Rhineland in 1774.

Mannheim was home to another Wittelsbach prince, the ambitious Elector Karl Philipp (reigned 1716–1742) who, with many a side-glance at the famous treasures of Düsseldorf, had built up an impressive collection. His successor, Carl Theodor (reigned 1742–99), a lover of art and spectacular display, considerably expanded it. While the main accent in Düsseldorf had been on Flemish masters, the collectors in Mannheim had chosen predominantly Dutch paintings, which consequently made up the greater part of the 758 pictures in the gallery. From there came Rembrandt's *Holy Family* (plate 92), an early, Baroque-style work dating from the 1630s which was particularly appealing to eighteenth-century taste, and which testifies to the passion with which this artist was collected at that time.

85 **Rembrandt Harmensz van Rijn**, detail of *The Holy Family* (plate 92)

Collectors were also fond of scenes of rural and peasant life, full of *joie de vivre*, which played an important role in festivities and re-enactments of the time and were therefore acquired in large numbers by the gallery. Adriaen van Ostade's peasant pieces, Jan Steen's *The Brawl* and a series of other famous paintings still retain their appeal for art lovers today. Numerous genre pieces, portraits, landscapes and still lifes are among the works which today testify to the important role played by Mannheim in building up the Alte Pinakothek's Dutch collection.

The Zweibrücken collection also arrived in Munich in 1799. The youngest of the Wittelsbach galleries, it had been assembled by Duke Karl August (reigned 1746–95), the last reigning prince of the region, for his castle of Carlsberg near Homburg. It is to his purchase that the Alte Pinakothek is indebted for Rembrandt's *Portrait of a Man in Oriental Costume* of 1633, whose theme must have appealed to the Duke's taste for the unusual. As well as the genre and peasant pieces, landscapes and still lifes which characterize the Dutch section of the Alte Pinakothek today, other pictures were bought in Zweibrücken whose acquisition clearly shows the change in taste towards the end of the century. These include landscapes by Jacob van Ruisdael and Hobbema, which testify to the English taste for the landscaped park that was taking the continent by storm.

Munich itself, which absorbed all these treasures in 1800 or thereabouts, also owned an impressive collection of Dutch paintings, most of which were housed in Schleissheim Palace. One of the most popular amongst them — the *Lady before a Glass* by Frans von Mieris — is particularly worth mentioning as an outstanding example of the 'fine art painting' so beloved of the eighteenth century.

Munich owes its astonishing riches in fine painting and miniaturists to the eighteenth century's ardent love of Dutch seventeenth-century painting, which afford an insight into Dutch perspectives and experience. This glorious development of the royal galleries was totally arrested, however, the moment they were united in Munich. Throughout the whole of the nineteenth century Dutch paintings were no longer systematically collected in Munich, unlike in other cities which zealously built up their galleries in accordance with the new discoveries in art history. Ludwig I's interests were directed towards other artists. Nevertheless, when his father Maximilian I's private collection was auctioned in 1826, Ludwig purchased several Dutch pictures, including works by Jacob van Ruisdael, Wouverman and Willem van de Velde. The fact that, in spite of the period of stagnation, the Alte Pinakothek possesses a considerable collection of Dutch Masters, which came to be appreciated only in the 'bourgeois period', is due not to the personalities of prominent collectors but in large measure to a political phenomenon. As a result of the secularization in the early nineteenth century, a great number of precious paintings passed into the hands of the State. Among these were major Dutch works by Rembrandt, Jan van Goyen and, most notably, Pieter Jansz Saenredam.

Not until the twentieth century was any attempt made to plug these gaps systematically. For instance, works by Frans Hals were acquired for the first time, and the important youthful self-portrait by Rembrandt was purchased.

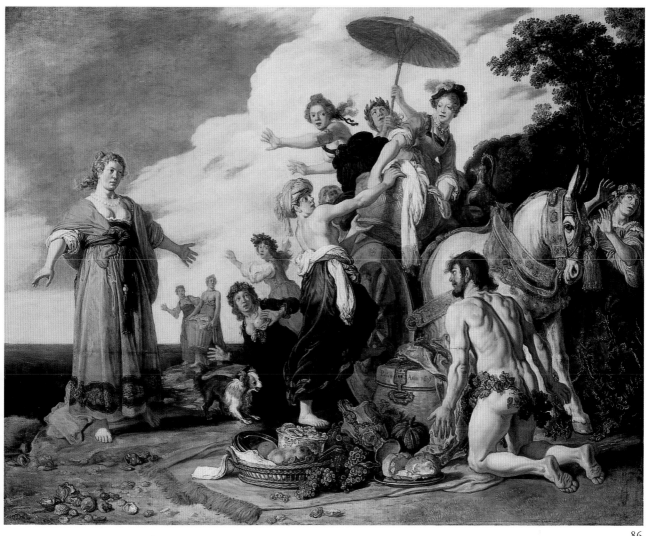

86

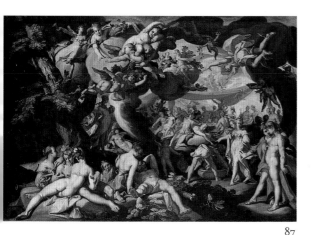

87

## 87
**Abraham Blomaert**
Gorinchem 1564–Utrecht 1651
*A Feast of the Gods*
c. 1595
Canvas
101 x 146 cm [6526]

After an etching by Hendrick Goltzius. A typical example of the late mannerist style practised internationally and frequently seen in the Imperial Court in Prague. From the Kurmainz gallery in Mainz.

## 86
**Pieter Lastman**
Amsterdam probably 1583–Amsterdam 1633
*Odysseus and Nausicaa*
signed and dated 1619
Oak
91.5 x 117.2 cm [4947]

Nausicaa, daughter of King Alcinous, grants the supplication of Odysseus who is stranded off the Phaeacian island of Scheria and entertains him with a display of oriental splendour. Purchased by Elector Karl Theodor from the Mannheim art dealer De Vigneux in 1792, seized by Napoleonic troops in 1800 and returned in 1815.

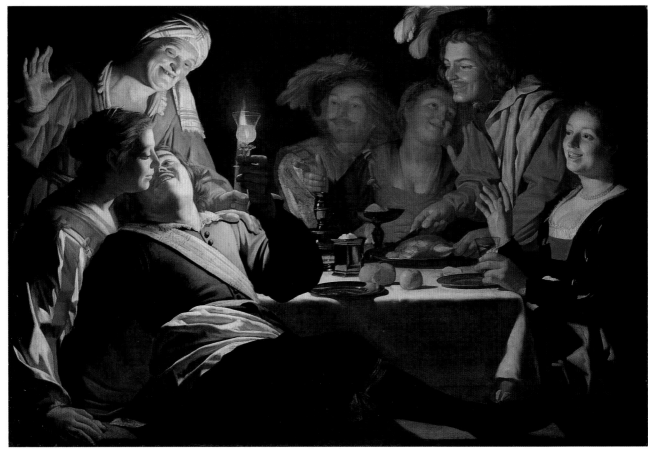

88

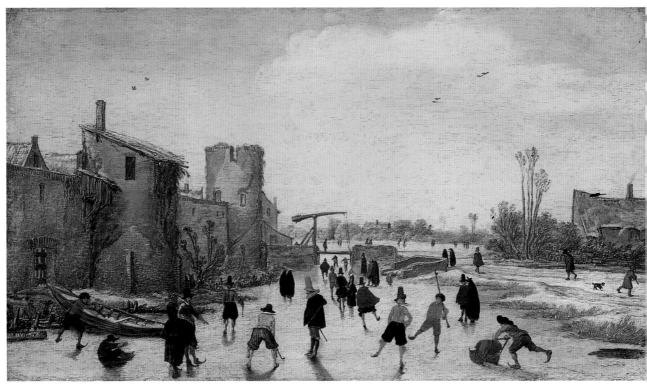

89

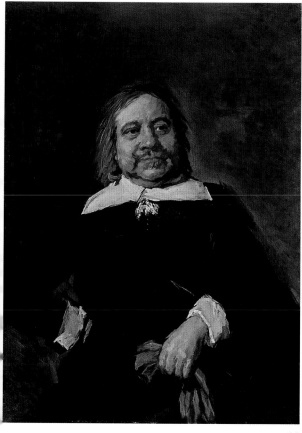

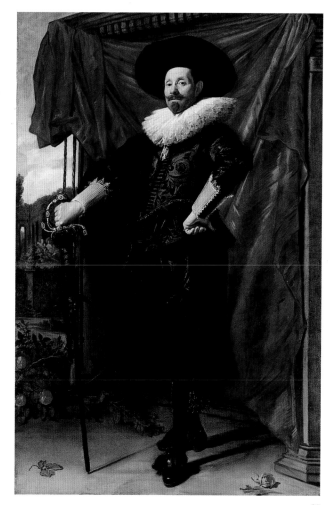

90

91

**88**
**Gerrit van Honthorst**
Utrecht 1590–Utrecht 1656
*Merry Round*
signed and dated 1622
Canvas
130 x 195.6 cm [1312]

The composition takes its centre
and its vivid theatrical liveliness
from the source of light.
Honthorst belonged to the group
of Utrecht Caravaggists and was
nicknamed 'Gherardo delle Notti'
in Italy on account of numerous
similar pictures. From the
Düsseldorf gallery.

**89**
**Esaias van de Velde**
Amsterdam *c.* 1591–The Hague
1630
*Games on the Frozen Moat*
signed and dated 1618
Oak
29.8 x 50.4 cm [2884]

An early example of the new
Dutch realistic landscape
painting, with folklore-based
features. From the Zweibrücken
gallery.

**90**
**Frans Hals**
Antwerp (?) 1581/85–Haarlem
1666
*Portrait of a Man*
signed *c.* 1660
Oak
47.1 x 34.4 cm [8402]

This portrait shows the light,
sketch-like, painterly brushstrokes
of the painter's late works, which
make do with a few shades of the
black, grey and brown range.
Acquired 1906.

**91**
**Frans Hals**
Antwerp (?) 1581/85–Haarlem
1666
*Willem van Heythuysen*
*c.* 1625/30
Canvas
204.5 x 134.5 cm [14101]

In the proud gait of the obviously
wealthy Haarlem yarn merchant,
dressed according to the latest
fashion, the painter combines the
supra-personal aspirations of the
social portrait with the precise
characterization of the individual.
The roses on the floor remind us
of the transience of earthly life.
Acquired from the collection of
the Prince of Liechtenstein in
Vaduz in 1969.

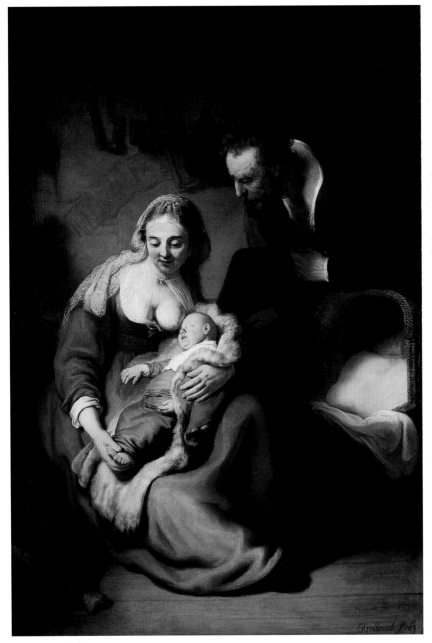

92

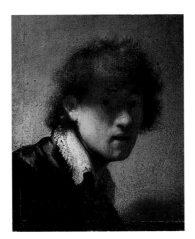

93

**92**
**Rembrandt Harmensz van Rijn**
Leiden 1606–Amsterdam 1669
*Holy Family*
signed and dated *c.* 1633
Canvas
183.5 x 123 cm  [1318]

No other painter before Rembrandt
had humanized the biblical theme
in this way. Purchased by the
court painter Lambert Krahe for
the Mannheim gallery in 1760.

**93**
**Rembrandt Harmensz van Rijn**
Leiden 1606–Amsterdam 1669
*Self-portrait*
signed and dated 1629
Canvas
15.5 x 12.7 cm  [11427]

This likeness of the 23-year-old
painter was to be followed by
numerous self-portraits in
Rembrandt's *oeuvre*, all of which
— in spite of profound artistic
changes — pose the persistent
question about the underlying
nature of existence. Purchased
from the family foundation of the
Dukes of Sachsen-Coburg-Gotha
in 1953.

94
**Rembrandt Harmensz van Rijn**
Leiden 1606–Amsterdam 1669
*The Descent from the Cross*
signed (?) probably 1633
West Indian cedar
89.4 x 65.2 cm [395]

From a series loosely held
together by the story of Christ,
painted for Stadholder (governor)
Frederik Hendrik of Orange.
Another five are in the Alte
Pinakothek. The composition
was inspired by the altarpiece
painted by Rubens for Antwerp's
Walpurgis church, but
Rembrandt's dramatically lit
composition emphasizes more
strongly Christ's human nature.
Below the figure of Christ is the
painter himself. Purchased by the
Elector Johann Wilhelm of the
Palatinate for the Düsseldorf
gallery.

95
**Carel Fabritius**
Miden-Beemster (near
Amsterdam) 1622–Delft 1654
*Self-portrait*
signed *c.* 1650
Canvas
62.5 x 51 cm (trimmed on all
sides) [2080]

The urgent self-questioning on
the one hand, with the spectacular
costume on the other, remind us
that the painter was trained in
Rembrandt's workshop (1641–43).
From the Prince Bishop's gallery,
Würzburg.

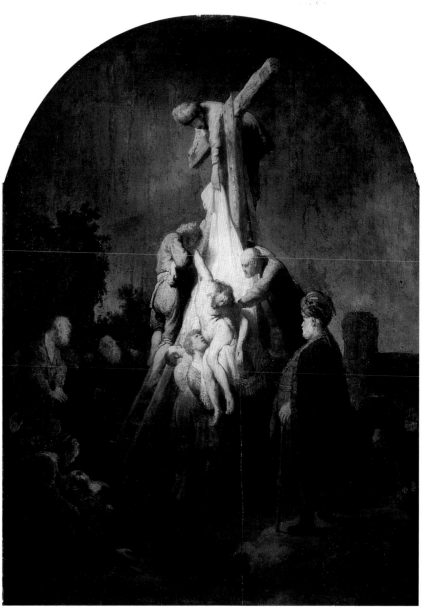

94

95

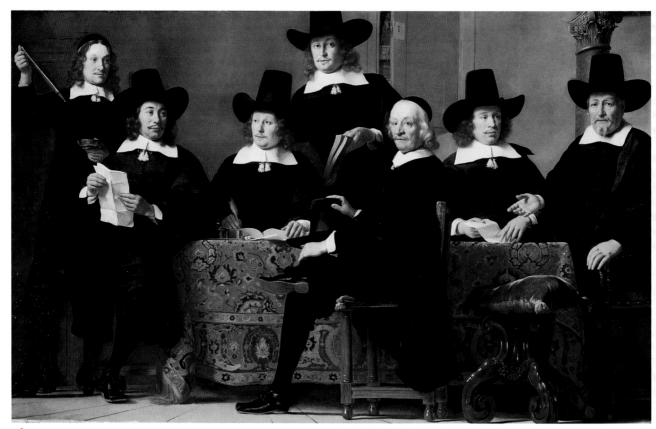

96

97

96
**Ferdinand Bol**
Dordrecht 1616–Amsterdam
1680
*The Senior Members of the Wine
Merchants' Guild*
probably 1659
Canvas
193.5 x 305 cm [9656]

Group portraits of august guilds
and members of governing
bodies were among the best paid
commissions of 17th-century
Dutch painters. Probably painted
in the founding year of the
Amsterdam guild in 1659. In the
possession of King Willem II of
the Netherlands until 1850.
Purchased in 1930.

97
**Aert de Gelder**
Dordrecht 1645–Dordrecht 1727
*Esther Before Going to Ahasuerus*
signed and dated 1684
Canvas
139.4 x 163.3 cm [841]

Esther, wife of the Persian king
Ahasuerus, valiantly rescued her
Jewish companions in the faith
from sore oppression and hence
passed into history as one of the
great figures of ancient times
(Old Testament: Book of Esther).
Although the fashion is that of
late 17th-century Europe, the
impression is nevertheless one of
oriental splendour. From the
Mannheim gallery.

98
**Gerard Ter Borch**
Zwolle 1617–Deventer 1681
*A Boy Picking Fleas from His Dog*
c. 1655
Canvas
34.4 x 27.1 cm [589]

The popularity of this genre
picture, with its extremely
delicate colours, is apparent from
the numerous copies made, even
in the 17th century. From the
Düsseldorf gallery.

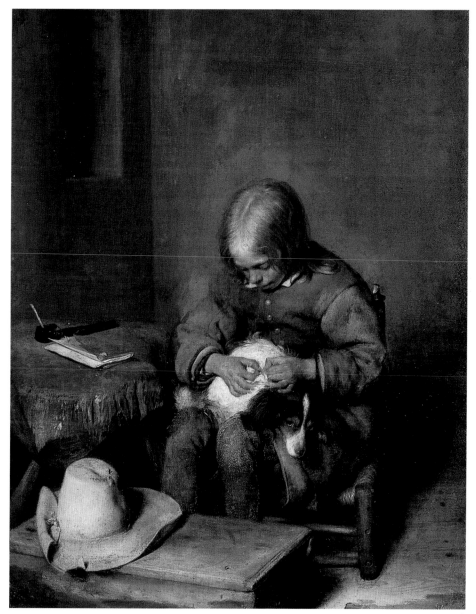

98

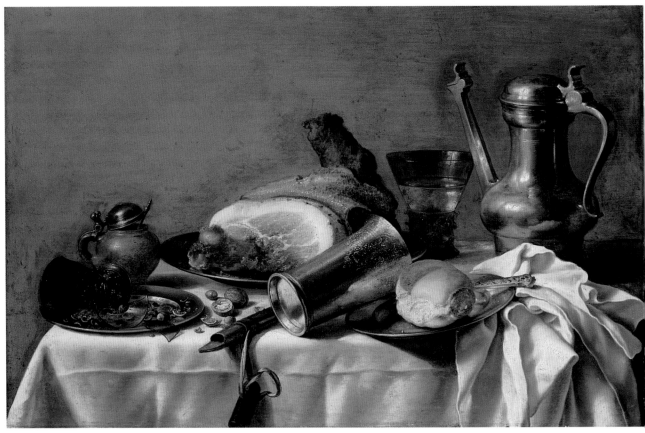

99

99
**Pieter Claesz**
Burgsteinfurt (Westphalia)
c. 1597–Haarlem 1660
*Still Life with Jug*
c. 1635
Oak
56 x 86.5 cm [157]

The 'Breakfast Still Life', usually
attuned to a small number of
subdued tones, played an
important part in Dutch painting
of the first half of the 17th century.
Several variants of this painting
by the artist himself are extant.
Purchased from the art dealer De
Vigneux in Mannheim in 1792.

100
**Pieter Jansz Saenredam**
Assendelft 1597–Haarlem 1665
*Interior of St Jacob's Church,
Utrecht*
signed and dated 1642
Oak
55.2 x 43.4 cm [6622]

The painter was interested in
the play of light on the bright,
unadorned plastered walls of
the church. He depicted only
one section of the most brightly
lit part of the choir. From the
Prince Bishop's gallery in
Würzburg.

101

102

101
**Adriaen van Ostade**
Haarlem 1610–Haarlem 1685
*Peasants Making Merry in a Tavern*
signed c. 1635
Oak
28.8 x 36.3 cm [864]

The companion piece *Men and Women in a Peasants' Tavern* is also in the Alte Pinakothek. Such pictures were painted for a sophisticated urban public of art connoisseurs who no longer had any links with the country-side, or the peasant's way of life, and were thus attracted by this milieu of 'primitive instincts'. From the Zweibrücken gallery.

102
**Pieter Janssens Elinga**
Bruges 1632–Amsterdam 1682
*Woman Reading*
c. 1660
Canvas
75.5 x 63.5 cm [284]

The light-suffused interior conveys quietness, comfort and security but also the widespread prosperity of the Dutch middle class in the 17th century. Purchased from the art dealer De Vigneux in Mannheim in 1791.

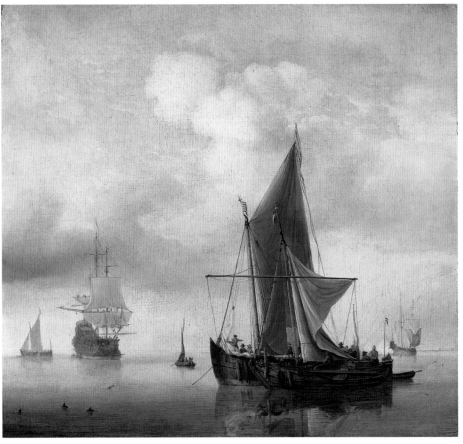

103

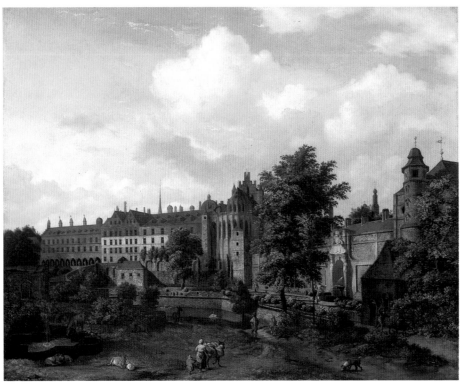

104

**103**
**Willem van de Velde the Younger**
Leiden 1633–Westminster 1707
*Calm Sea*
c. 1655
Canvas
51.6 x 56.5 cm  [1032]

The extremely restrained colour range suits the dead calm which has brought the ships to a standstill, giving an impression of supremely harmonious balance. This seascape illustrates the importance of Holland as a sea power. From King Maximilian I's collection.

**104**
**Jan van der Heyden**
Gorinchem (Gorkum)
1637–Amsterdam 1712
*The Old Palace in Brussels*
c. 1665
Oak
50.8 x 63.5 cm  [7287]

A topographically accurate architectural *veduta*. The palace served as a residence for the sovereign (also for the Bavarian Elector Max Emanuel when he was governor of the Netherlands). From the Residenz gallery in Ansbach.

105
**Salomon van Ruysdael**
Narden 1600/3–Haarlem 1670
*River Landscape with Ferry Boat*
c. 1630/35
Oak
65.6 x 94.4 cm [161]

Realism and poetry in equal
measure are shown in this
treatment of a river scene as
setting for a Dutch peasant.

106
**Philips Koninck**
Amsterdam 1619–Amsterdam
1688
*Flat Landscape*
c. 1650/55
Canvas
133.3 x 165.7 cm [9407]

A wide, flat, Dutch landscape
with a low horizon, in which the
overcast sky stands out as the
main element. Purchased from
art dealers in Munich in 1927.

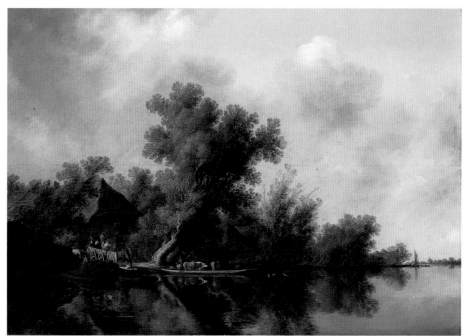

105

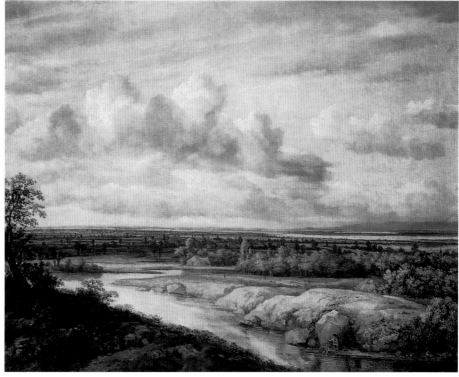

106

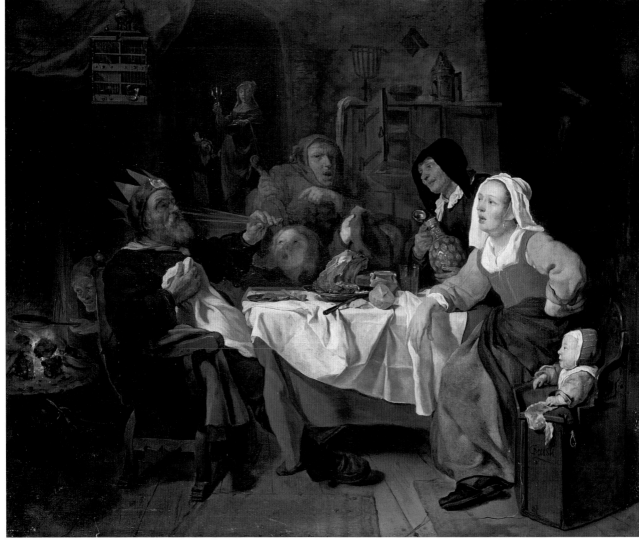

107

107
**Gabriel Metsu**
Leiden 1629–Amsterdam 1667
*The Bean Feast*
c. 1650/55
Canvas
80.9 x 97.9 cm [871]

According to popular Nether-
landish tradition, the person who
found a bean hidden in their cake
on Twelfth Night was crowned
'Bean King'. Occasionally the
Kingship also fell to him by lot,
in which case this was then
pinned to the paper crown as in
this picture. From the Düsseldorf
gallery.

108
**Jan Baptist Weenix**
Amsterdam 1621–Huis ter May
(near Utrecht) c. 1660
*Sleeping Girl*
signed and dated 1656
Canvas
66 x 54 cm [869]

Among the Schildersbent or
Bentvueghels, a group of
Netherlandish artists in Rome,
the painter found his own style,
which was strongly influenced by
the bright Southern light. From
the Düsseldorf gallery.

109
**Karel Dujardin**
probably Amsterdam c. 1620–
Venice 1678
*The Sick Goat*
signed c. 1665
Canvas
84.5 x 73 cm [291]

The anecdotal title was given
to the picture only in the 19th
century. To this day it has not
been possible to interpret
precisely its actual content, no
doubt tinged with eroticism.
From the Mannheim gallery.

110
**Philips Wouwerman**
Haarlem 1619–Haarlem 1668
*Winter Landscape with Ice*
signed 1655/60
Oak
47.5 x 63.7 cm [152]

Popular amusements on ice are
among the favourite themes of
Dutch genre painting. The white
horse is nearly always present in
Wouwerman's work. From the
Zweibrücken gallery.

108

109

110

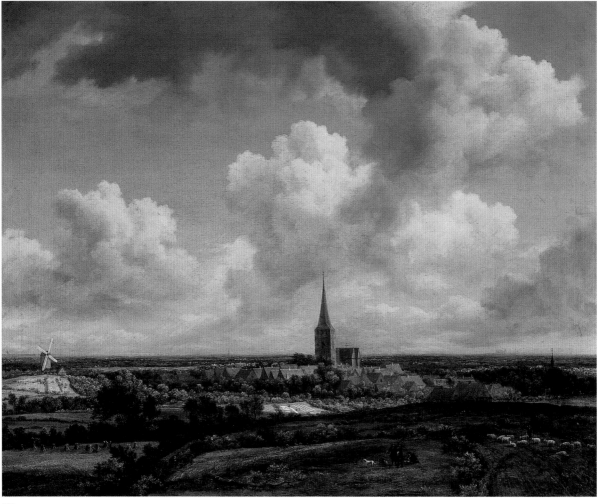

III

II2

III
**Jacob van Ruisdael**
Haarlem 1628/29–Amsterdam
(?) 1682
*View of Ootmarsum*
c. 1670/75
Canvas
59.1 x 73.2 cm  [10818]

A broad, flat landscape with
allusions to the human scene
dominated by God and the
elements. Purchased from the
collection of Prince Ernst von
Sachsen-Meiningen, 1942.

II2
**Jan Steen**
Leiden 1625/26–Leiden 1679
*The Love-sick Girl*
c. 1660
Canvas
61 x 52.1 cm

In the love-sick girl's hand there
is a slip of paper with the text
'Daar baat geen medesyn, want
het is minepyn' (Against love-
sickness no medicine can help).
From the Düsseldorf gallery.

113

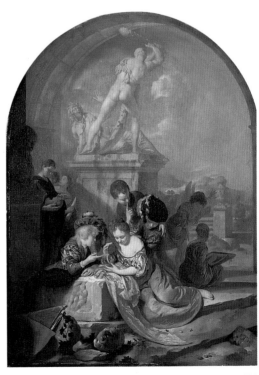

114

113
**Nicolas Berchem**
Haarlem 1620–Amsterdam 1683
*Italian Landscape in the Evening Light*
signed *c.* 1670/75
Oak
41.2 x 54.5 cm [266]

Alongside Claude Lorrain, it was the Dutch Italianists who introduced into Northern painting the conception of a warm, sun-drenched landscape. From the Elector's gallery.

114
**Adriaen van der Werff**
Kralingen, near Rotterdam
1659–Rotterdam 1722
*Children Playing in front of a Statue of Hercules*
signed and dated 1687
Oak
(with rounded top edge) 46.8 x 35 cm [250]

This picture, to be interpreted as a moral allegory, could also be entitled 'In praise of virtue and down with vice'. From the Düsseldorf gallery.

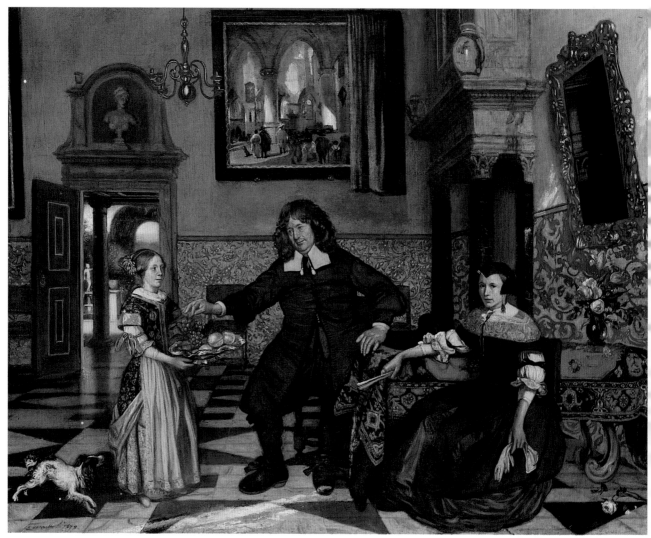

115

115
**Emanuel de Witte**
Alkmaar 1616/18–Amsterdam
1692
*Family Portrait*
signed and dated 1678
Canvas
68.5 x 86.5 cm [FV 2]

Here the painter, who is chiefly
famous for his church interiors,
portrays the rich Dutch
bourgeoisie in the 17th century,
with its strict Protestant morality.
Purchased by the Friends of the
Alte Pinakothek in 1972.

116
**Frans van Mieris**
Leiden 1635–Leiden 1681
*Lady at the Mirror*
c. 1670
Canvas
43 x 31.5 cm [219]

The mirror, symbol of vanity,
reminds the lively young lady of
the transience of all earthly things.
From the Elector's gallery.

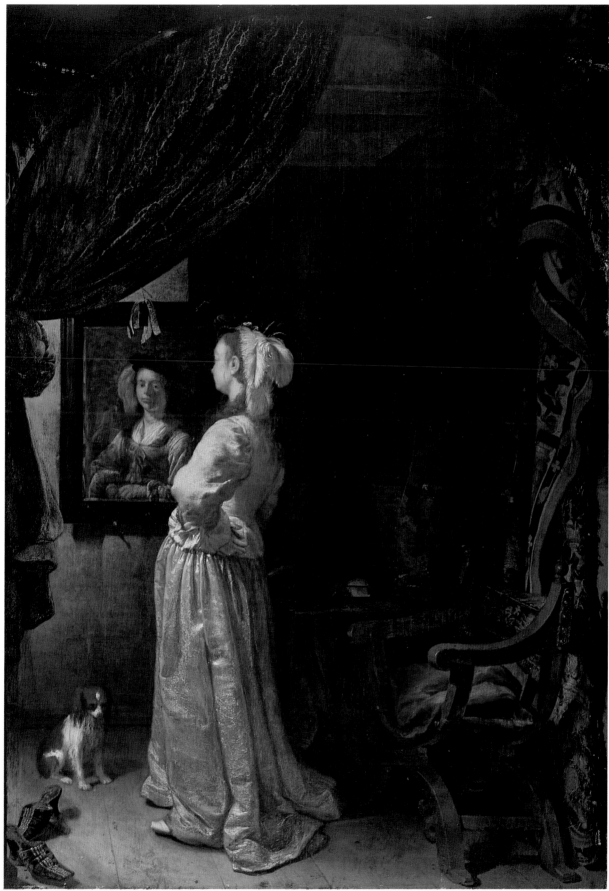

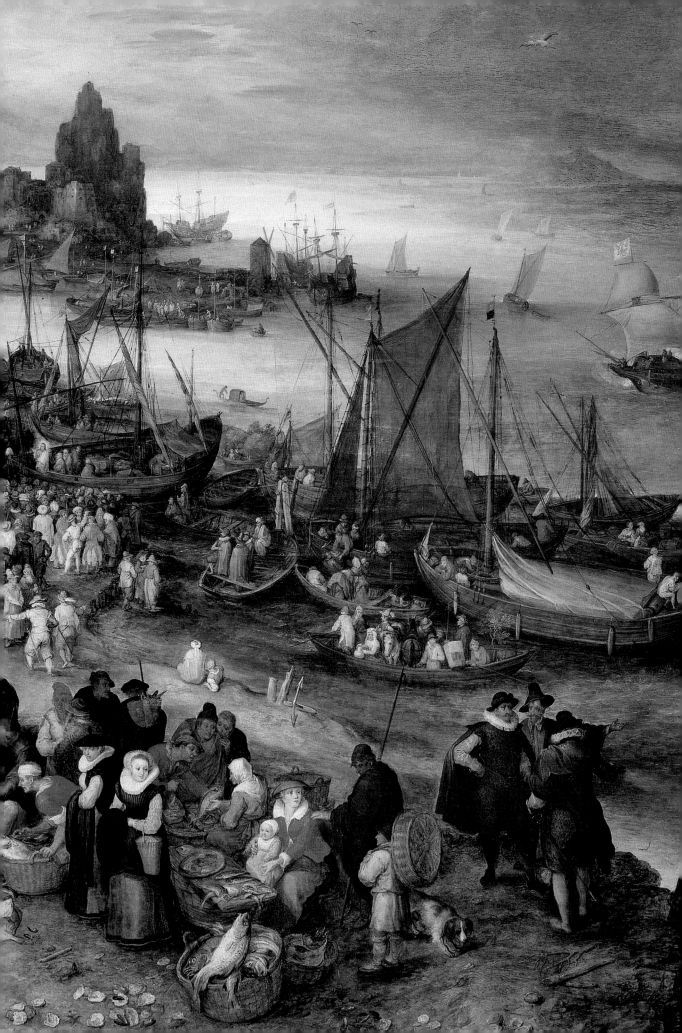

# Flemish Painting

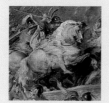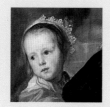

One of the most important departments in the Alte Pinakothek is that of Flemish Baroque painting, particularly of the seventeenth century. Its focal point is the Rubens collection, one of the greatest anywhere in the world. The nucleus of this goes back to the commissions given to Rubens by the Bavarian princes and bishops, and it should be borne in mind that Elector Maximilian I and his brother-in-law, Wolfgang Wilhelm of Pfalz-Neuburg, were the only German princes for whom Rubens carried out commissions.

In 1616 he painted the cycle of four hunting pictures for Maximilian to decorate the old Palace of Schleissheim; after their seizure in the Napoleonic wars only one of these, *The Hippopotamus and Crocodile Hunt*, was returned to Munich. Commissioned by Duke Wolfgang Wilhelm of Pfalz-Neuburg (reigned 1611–53), Rubens painted four altarpieces for the newly built Jesuit church in Neuburg on the Danube between 1616 and 1619, among them the famous *'Large' Last Judgment*. This latter was covered up in the very year of the duke's death, on account of its 'offensive nudity'. The duke's grandson, Elector Johann Wilhelm (reigned 1690–1716), who resided in Düsseldorf, managed, by dint of much hard work, to wrest these pictures from the church authorities and incorporate them into his newly created Düsseldorf collection.

Besides a number of Italian and Dutch works, Johann Wilhelm's gallery contained mainly Flemish masters, forty-six of them bearing the name of Rubens. Johann Wilhelm's tenacity in pursuing his goals is demonstrated by the efforts he made over many years to incorporate the pictures commissioned by his grandfather for the church of the Jesuits in Neuburg into his gallery in Düsseldorf.

Johann Wilhelm maintained innumerable contacts with various agents in the Netherlands so that he could buy pictures by Rubens at every opportunity — according to contemporary reports, the prices of Rubens' paintings rose by more than half as a result of his zeal. Some of the pictures were purchased directly from churches without the need for negotiations with private collectors, although this was not without hard bargaining, in the course of which Johann Wilhelm often had to undertake to provide copies or replacements in the form of other paintings.

Because of the extraordinarily early stage at which it was publicized, the Düsseldorf gallery was strongly imprinted on the consciousness of art-lovers all over the world. The descriptions of the pictures penned by *Sturm und Drang* writer Johann Jakob Heinse (1776–77) and Enlightenment author Georg Forster (1790) number amongst the literary masterpieces of early art criticism. In 1906, through family succession and following peregrinations necessitated by war, the collection arrived in Munich.

The fame of the Düsseldorf gallery often leads us to forget that many Flemish paintings, including a number

117 **Jan Brueghel the Elder**, detail of *Harbour with Christ Preaching* (plate 119)

of quite important works by Rubens, were acquired from the Bavarian elector Max Emanuel (reigned 1679–1726). These included the sixteen sketches for the Medici cycle first mentioned in Munich in 1729, and the famous *Lion Hunt* (plate 124), the sketch for which was bought in 1995. In 1698, Max Emanuel purchased 101 paintings for 90,000 florins from the Netherlandish merchant Gisbert Van Colen.

It is possible that through a relationship with the Fourment family — Fourment was the family name of Rubens' second wife Hélène — Van Colen was able to gain possession of private Rubens pictures which Rubens had never intended for sale but always kept in his own house, including four portraits of Hélène. These family testaments took their place in Munich beside other pictures from the private sphere of Rubens' life, such as the self-portrait with his first wife Isabella Brant, the famous *Honeysuckle Bower* (plate 121) from Düsseldorf.

The Alte Pinakothek offered the most complete and most accessible collection for critical Rubens research, which took shape in the nineteenth and early twentieth century, mainly in Germany, and it has therefore had a determining influence on our image of the artist.

One of the gems of the Alte Pinakothek is the Brouwer Collection. This group of seventeen masterpieces by the brilliant painter of peasant life, whose works were already much sought after during his lifetime — and who was very highly regarded by Rubens and Rembrandt — is by far the most extensive in existence.

The name of Jan Brueghel, the second eldest son of Pieter Bruegel the Elder, and a collaborator of Rubens, should also be mentioned here. The rich collection of thirty paintings, mainly from the Elector's and the Mannheim galleries, is probably not only the largest but with its fresh, exquisite pictures also one of the finest groups by this master, whose flower pieces and landscapes have long been highly esteemed — and bought for swinging sums — by collectors throughout Europe.

The transfer of the various Wittelsbach galleries to Munich at the end of the eighteenth and the beginning of the nineteenth centuries increased the Flemish department of the Alte Pinakothek to its present size. Only a few individual pictures have been added. In 1804, in the course of the secularization, Rubens' high altarpiece from the cathedral of Freising, *The Apocalyptic Woman*, came to Munich. Commissioned by the Prince Bishop of Freising and painted around 1624–25, this work accords well with the other religious pictures from Neuburg.

The large collection of Netherlandish paintings of the sixteenth century, by artists such as Reymerswaele and Sanders van Hemessen, dates back to Elector Maximilian I. The majority are Italian-influenced compositions. The most important painting, executed by the greatest artist of this period, Pieter Bruegel the Elder — *The Land of Cockaigne* (plate 118) — was acquired in 1917. For centuries Bruegel's pictures had been accorded the highest acclaim — by Rubens, among others — and had also ranked among the greatest rarities right from the time when Emperor Rudolf, from whose collection the Munich picture had originally come, had been almost fanatical in buying them up. The collections thus contain impressive representatives of the two trends of sixteenth-century Netherlandish art that formed the basis for Flemish Baroque painting.

**118**
**Pieter Bruegel the Elder**
Breda (?) *c.* 1525–Brussels 1569
*The Land of Cockaigne*
signed and dated 1566
Oak
52 x 78 cm [8940]

As Hans Sachs has pointed out,
worry and toil are unknown in
the Land of Cockaigne, just as
they are in Hesiod's Golden Age,
in Virgil's Arcadian fields and in
the Garden of Eden. Yet the moral
warning must not be overlooked:
gluttony and drunkenness, in
which all ranks indulge, lead to
sloth and apathy. Purchased in
1917. Formerly in Prague's
Imperial collection, from which it
was taken by the Swedes in 1648.

**119**
**Jan Brueghel the Elder**
Brussels 1568–Antwerp 1625
*Harbour with Christ Preaching*
signed and dated 1598
Oak
78 x 119 cm [187]

Around 1600 Brueghel was
painting panoramic 'world
landscapes' with an abundance
of figures and with raised
horizons, before going over to
the new portrait-like conception
of landscape of the 17th century
which is to be seen in his
*Landscape with Windmills*.
From the Mannheim gallery.

**120**
**Cornelis van Dalem**
Antwerp (?) *c.* 1530/35–Breda (?)
1573
*Landscape with Farmstead*
signed and dated 1564
Oak
103 x 127.5 cm [12044]

The impression made by this
painting is surprisingly modern
and unconventional, on account
of its unpretentious subject
matter. The pictorial treatment
has strong emotional appeal.
Purchased from a private owner
in Munich in 1954.

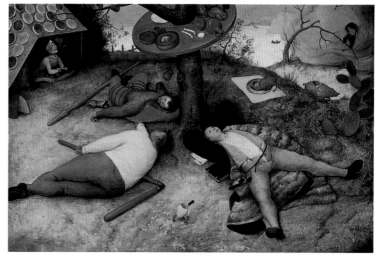

118

119

120

121

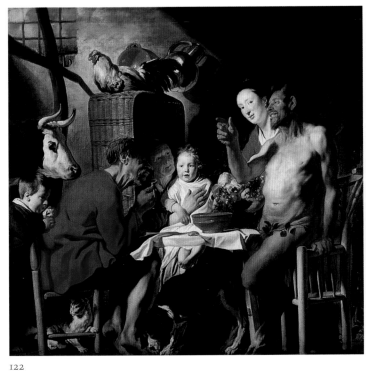

122

121
**Peter Paul Rubens**
Siegen (Westphalia)
1577–Antwerp 1640
*Rubens and Isabella Brant in
the Honeysuckle Bower*
*c.* 1609/10
Canvas mounted on wood
178 x 136.5 cm [334]

On 3 October 1609, Rubens
married the eighteen-year-old
daughter of the Antwerp patrician
and City Clerk Jan Brant. Honey-
suckle has been a well-known
symbol of married love since the
Middle Ages, and the linked right
hands are also indicative of the
married state. This early work of
the master — one of the most
tender marriage portraits in the
history of art —was probably
originally intended for the bride's
parents. From the Düsseldorf
gallery.

122
**Jacob Jordaens**
Antwerp 1593–Antwerp 1678
*Satyr in the Peasant's House*
after 1620
Canvas on oak
174 x 205 cm [425]

From *Aesop's Fables* (LXXIV),
Jordaens went back repeatedly
to this theme. The lively *verismo*
treats Caravaggio's revolutionary
art in a native Flemish manner.
From the Düsseldorf gallery.

123
**Abraham Janssens**
Antwerp 1573/74– Amsterdam
1632
*Olympus*
*c.* 1620
Canvas
207 x 240 cm [4884]

Venus, denounced by Hera, is
defending herself before Zeus
and the court of the Gods.
Janssens' coming to terms with
Caravaggio's *verismo* is evident,
just as it is in the early Rubens,
in the buxom solidity of the
figures. From the Elector's gallery
in Munich.

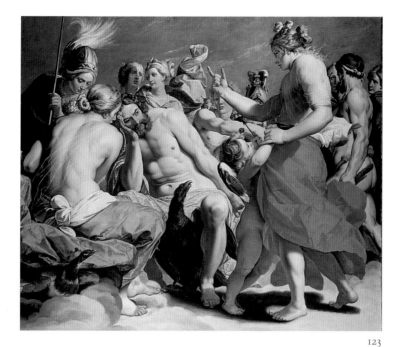

123

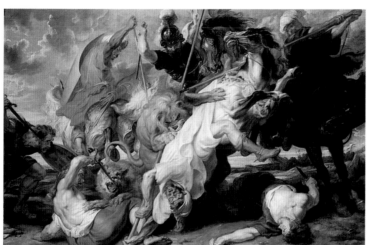

124

124

**Peter Paul Rubens**
Siegen (Westfalen) 1577 –
Antwerpen 1640
*Lion Hunt*
1621
Canvas
249 x 377 cm [602]

Rubens wrote in September 1621:
'I have almost completed a large-scale painting — executed
entirely by my own hand —
which I believe to be of the best,
and which depicts a lion hunt...'
Amongst Rubens' many hunting
pictures, this one displays
exceptional quality.  It turns the
event into a thrilling portrayal of
the emotions, concentrating the
action on the single moment in
which the struggle must have
been decided. From the Electors'
gallery, Munich.

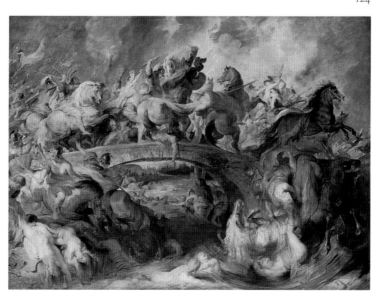

125

125

**Peter Paul Rubens**
Siegen (Westphalia)
1577–Antwerp 1640
*The Battle of the Amazons*
before 1619
Oak
121 x 165 cm [324]

The nature of the struggle
between the Greeks and the
warrior women of Asia Minor
cannot be precisely determined,
although represented here in
detail. Ancient sarcophagus
reliefs and especially Leonardo's
lost cartoon for the *Battle of
Anghiari* play an important part
in this brilliant composition.
From the Düsseldorf gallery.

126
**Peter Paul Rubens**
Siegen (Westphalia)
1577–Antwerp 1640
*The Rape of the Daughters
of Leukippos*
*c.* 1618
Canvas
224 x 210.5 cm  [321]

The legend handed down by
Theocritus, Ovid and Hyginus
provides the painter with a
welcome pretext to extol manly
strength and luscious female
beauty in an artistic, baroque-
centred composition. Purchased
by Elector Johann Wilhelm of
the Palatinate for the Düsseldorf
gallery before 1716.

127
**Peter Paul Rubens**
Siegen (Westphalia)
1577–Antwerp 1640
*Polder Landscape with Herd
of Cows*
*c.* 1618/20
Oak
81 x 106 cm  [322]

The fertile Flemish soil found
its highest artistic expression
in Rubens' polder landscapes.
Purchased by Elector Max
Emanuel from the Antwerp
tradesman Gisbert van Colen
in 1698, in a lot of 101 mostly
Flemish paintings, amongst
which were twelve by Rubens.

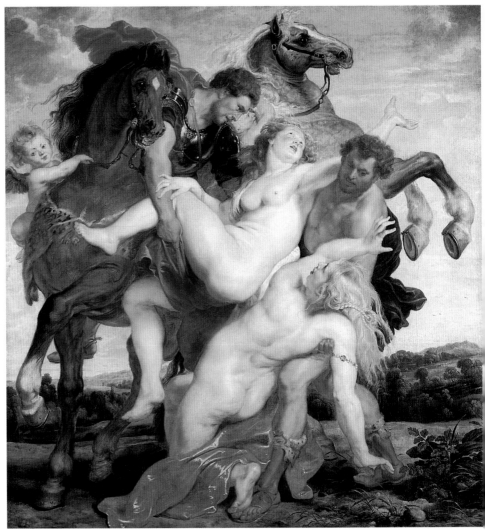

126

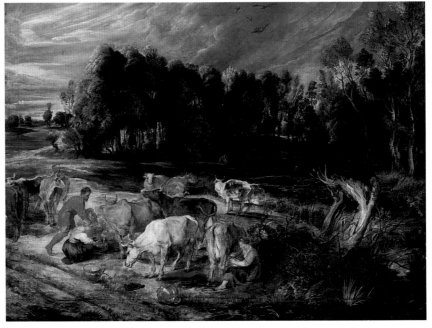

127

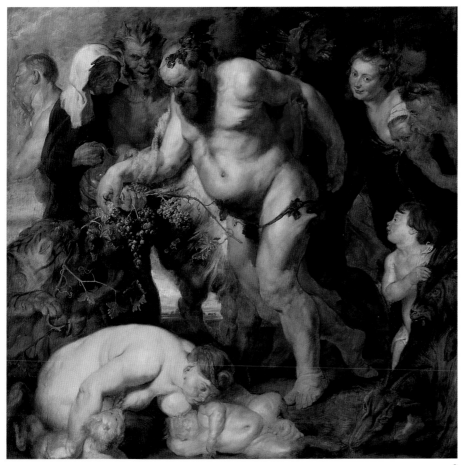

128

128
**Peter Paul Rubens**
Siegen (Westphalia)
1577–Antwerp 1640
*The Drunken Silenus*
c. 1617/18 (a piece added in 1626)
Oak
205 x 211 cm  [319]

One of the band of Sileni
belonging to the retinue of the
god Dionysos is Silenus, his
tutor. His features bear a striking
resemblance to those of Socrates,
who was repeatedly portrayed as
Silenus in ancient times. Recorded
as being in the Düsseldorf gallery
from about 1716.

129
**Peter Paul Rubens**
Siegen (Westphalia)
1577–Antwerp 1640
*Landing in Marseilles (3.11.1600)*
c. 1621/22
Oak
64 x 50 cm  [95]

Maria de' Medici was married
to King Henry IV of France in
October 1600 and after his
assassination, on 14 May 1610,
she conducted the business of
state (the Dauphin was still a
minor). The cycle of paintings
executed for the Palais du
Luxembourg, built between 1612
and 1620, is one of the most
significant secular apotheoses of
the Baroque period. The twenty-
one monumental paintings,
completed in 1625, are now in
the Louvre. The Alte Pinakothek
has sixteen coloured sketches,
others are in the Hermitage in St
Petersburg. From the Elector's
gallery in Schleißheim.

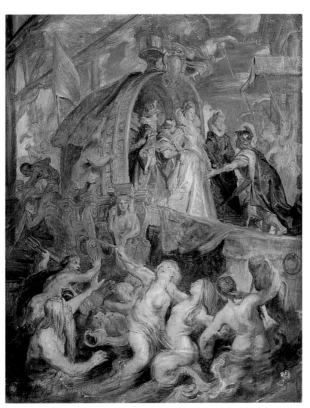

129

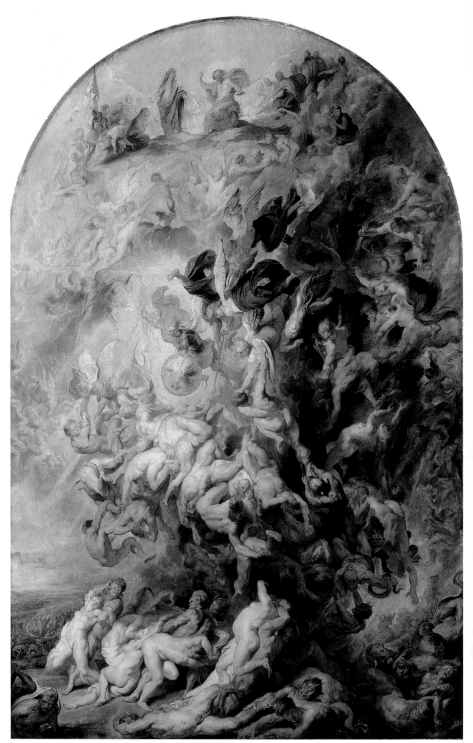

130

130
**Peter Paul Rubens**
Siegen (Westphalia)
1577–Antwerp 1640
*'Small' Last Judgment*
c. 1620
Oak, with rounded upper edge
183 x 120 cm [611]

Based on the account in Matthew
24, 30-32, 35, 31-46, this picture
is akin to the slightly earlier *'Large'
Last Judgment*, also in the Alte
Pinakothek. From the Düsseldorf
gallery.

131
**Peter Paul Rubens**, detail of
*'Small' Last Judgment* (plate 130)

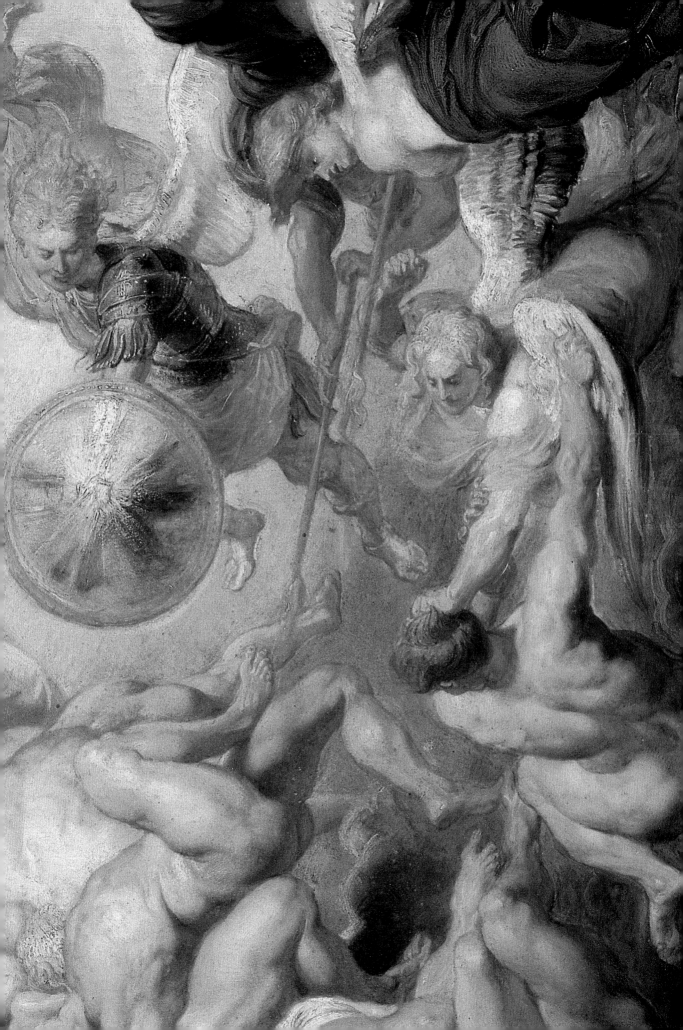

132

133

**132**
**Peter Paul Rubens**
Siegen (Westphalia)
1577–Antwerp 1640
*The Massacre of the Innocents*
c. 1635/40
Oak
199 x 302 cm [572]

The cruel spectacle receives its
most heightened dramatic
treatment in this artistically
presented late work. Purchased
by Elector Max Emanuel for the
Schleissheim gallery before 1706.

**133**
**Peter Paul Rubens**
Siegen (Westphalia)
1577–Antwerp 1640
*Hélène Fourment in Her
Wedding Dress*
c. 1630/31
Oak
163.5 x 136.9 cm [340]

The artist's second wife, daughter
of an Antwerp merchant, whom
he married on 6 December 1630,
is represented as a sixteen-year-
old bride in a sumptuous brocade
dress, a head-dress set with pearls
and jewels, and all the other
requisites of a princely baroque
portrait. Purchased by Elector
Max Emanuel from Gisbert van
Colen in 1698.

**134**
**Peter Paul Rubens**, detail of
*The Massacre of the Innocents*
(plate 132)

135

136

135
**Sir Anthony van Dyck**
Antwerp 1599–London 1641
*The Wife of the Painter Theodor Rombouts and Her Daughter*
*c.* 1632
Oak
122.8 x 90.7 cm [599]

Companion piece to the portrait of the painter Theodor Rombouts, also in the Alte Pinakothek. Purchased by Elector Max Emanuel from Gisbert van Colen in 1698.

136
**Sir Anthony van Dyck**
Antwerp 1599–London 1641
*The Painter Jan de Wael and His Wife Gertrude de Jode*
1627/32
Canvas
125.3 x 139.7 cm [596]

Although no authenticated paintings of the once-esteemed Antwerp painter are now known, Van Dyck has here created, with fine psychological intuition, one of the most impressive portraits of a married couple in European baroque painting. Purchased by Elector Max Emanuel from Gisbert van Colen in 1698.

137
**Adriaen Brouwer**
Oudenaarde 1605/6–Antwerp 1638
*Peasants Playing Cards in a Tavern*
*c.* 1631/32
Oak
33 x 43 cm [218]

Brouwer's genre scenes were much admired by Rubens and their clay-like colours gave rise to a school in the 19th century. They portray not only the everyday lives of Flemish peasants but also, with their allusions to the evils of gambling, drinking and gluttony, have a pervading moral content. Purchased by Elector Max Emanuel from Gisbert van Colen in 1698.

138
**Sir Anthony van Dyck**
Antwerp 1599–London 1641
*The Rest on the Flight into Egypt*
*c.* 1627/32
Canvas
134.7 x 114.8 cm [555]

The exceptional humanization of the religious theme makes this picture one of the most popular exhibits in the Alte Pinakothek. The encounter with Venetian painting is unmistakable. Probably painted for the artist's brother Theodor, a Canon of St Michael's church in Antwerp. Purchased by Elector Max Emanuel.

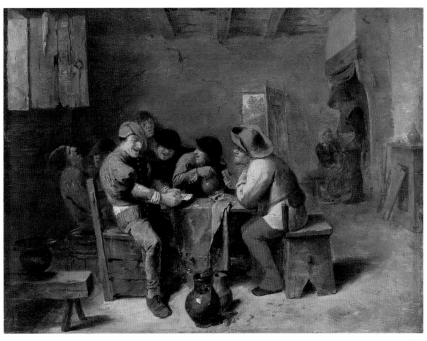

137

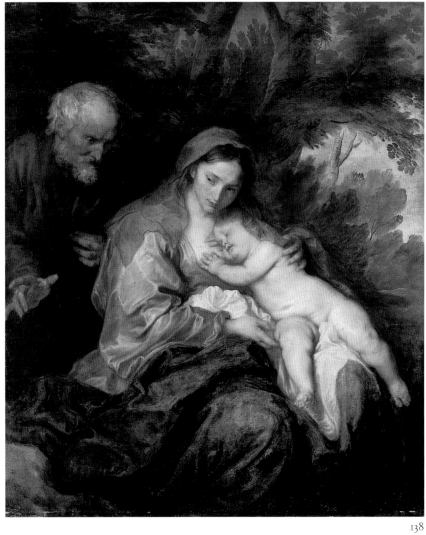

138

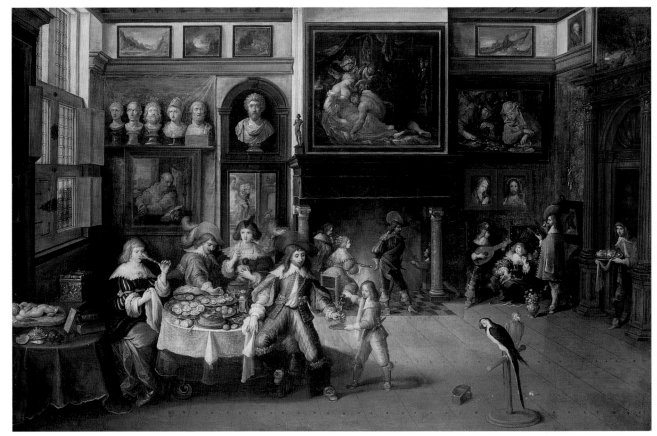

139

139
**Frans II Francken**
Antwerp 1581–Antwerp 1642
*Banquet at the House of
Bürgermeister Rockox*
signed 1630/35
Oak
62.3 x 96.5 cm [858]

This depiction of the *Kunst-kammer* (art gallery) belonging
to the prosperous Bürgermeister
gave the artist the opportunity
to represent all five senses: sound
(lute player), sight (man with
spectacles), smell (woman
smelling a flower), taste (wine
drinker) and touch (people
warming themselves at the fire-
place). From the Düsseldorf
gallery.

140
**Adriaen Brouwer**
Oudenaarde 1605/6–
Antwerp 1638
*Peasants Smoking and Drinking*
c. 1635
Oak
35 x 26 cm [2062]

Purchased by Elector Max Emanuel
from Gisbert van Colen in 1698.

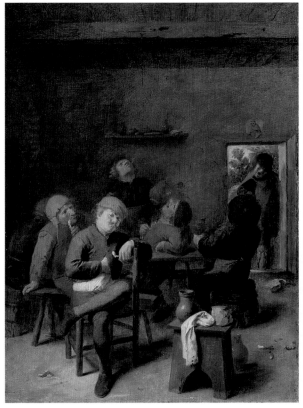

140

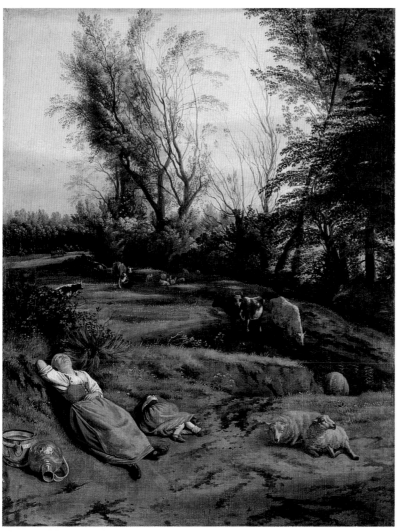

141

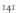

142

**141**
**Jan Siberechts**
Antwerp 1627–London 1710
*Cow Pasture with Sleeping
Woman*
after 1660
Canvas
107 x 83 cm [2165]

The cool, silvery colour and
the intimacy of the detail
anticipate features which would
again characterize the land-
scape painting of the French
realists around the middle
of the 19th century. From the
Zweibrücken gallery.

**142**
**Jan Davidsz de Heem**
Utrecht 1606–Antwerp (?)
1683/4
and **Nicolaes van Veerendael**
Antwerp 1640–Antwerp 1691
*Still Life with Flowers, Crucifix
and Skull*
signed *c.* 1665
Canvas
103 x 85 cm [568]

The *vanitas* still life warns us
of the transience of all earthly
things and promises resurrection
through Christ's death on the
cross. Purchased by Elector Max
Emanuel from Gisbert van Colen
in 1698.

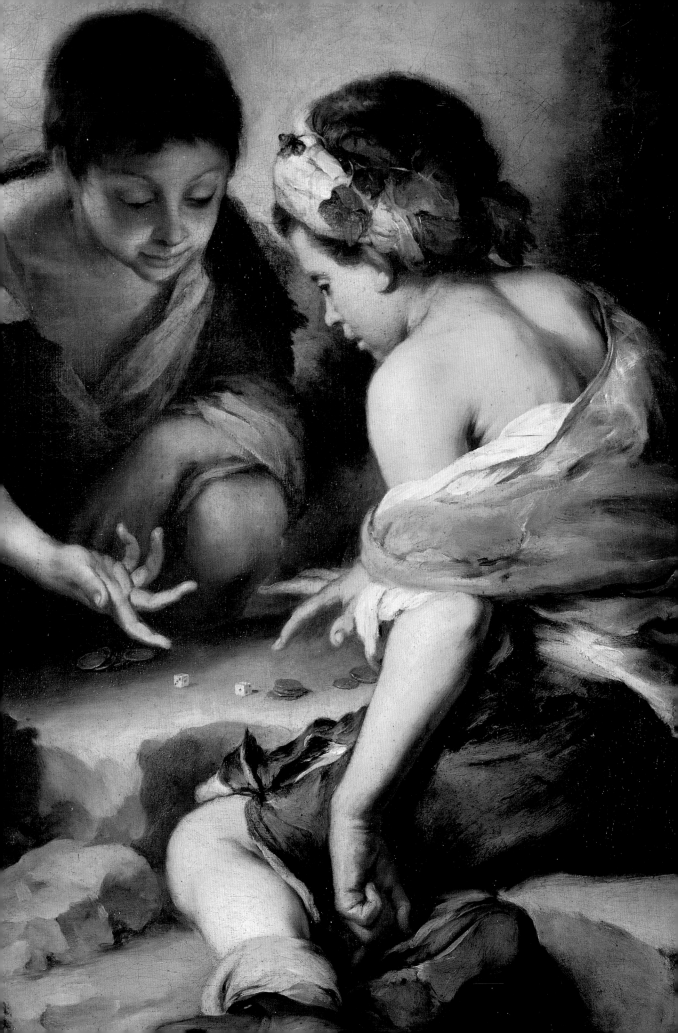

# Spanish Painting

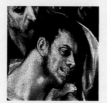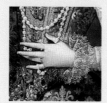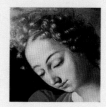

With just twenty-two paintings, the Spanish section in the Alte Pinakothek is the smallest, but also one of the most complete, as every important master is represented. The oldest paintings in the collection include the portraits of Albrecht the Pious and his consort, the Infanta Clara Eugenia of Spain (painted by Pantoja de la Cruz in 1600), which found their way to Munich from the monastery of Hohenwart in 1804 as a result of the secularization. *The Disrobing of Christ* by El Greco (plate 146) was purchased by Hugo von Tschudi in 1909. Elector Max Emanuel bought two genre pictures by Murillo in Antwerp when he was Spanish governor of the Netherlands — one, *The Grape and Melon Eaters* (plate 151) as early as 1691 and the other, *Boys Playing Dice* (plate 152) in 1698 — and thus laid the foundations of the famous set of Murillos in Munich. The addition to the Murillo collection of *The Little Fruit-Seller* and *Domestic Grooming* in the reign of Elector Maximilain III Josef (1727–77) was due to the generosity of court chamberlain Franz Joseph von Dufresne, who left these works to the gallery in 1768. Zurbarán's *St Francis in Ecstasy* (plate 149), Ribera's *St Peter of Alcántara* and the fifth of Murillo's genre pictures, *The Pastry Eaters*, came to Munich with the Mannheim gallery. The fact that a painting by Zurbarán found its way into a gallery outside Spain as early as the eighteenth century is unusual, since this painter did not gain European recognition until the nineteenth century, but in fact the purchase was due to an error — the *St Francis* was thought to be a major work by Guido Reni.

From the Düsseldorf gallery came the *Young Spanish Nobleman* by Velázquez (plate 144), which had been purchased by Elector Johann Wilhelm. Along with his contemporary Elector Max Emanuel, he was the first to include Spanish pictures in his collections. King Maximilian I Joseph of Bavaria not only united the various Wittelsbach collections in one gallery, but also made considerable sums of money available for new acquisitions. As a result, Crown Prince Ludwig was able to purchase important paintings in Paris for the Spanish collection — including *St Peter of Alcántara Walking over the Guadiana River* by Claudio Coello and *The Virgin Appearing to St Anthony* by Alonso Cano. The latest addition to the Spanish room, in 1985, was Zurbarán's *The Entombment of St Catherine of Alexandria on Mount Sinai* (plate 150), which dates from about 1636.

143 **Bartolomé Esteban Murillo**, detail of *Boys Playing Dice* (plate 152)

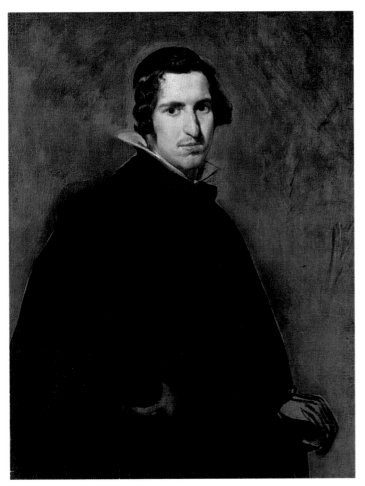

144

**Diego Rodriguez de Silva y Velázquez**
Seville 1599–Madrid 1660
*Young Spanish Nobleman*
probably 1623/30
Canvas
89 x 69 cm [518]

Unfinished: only the head, collar and background have been worked. The still-perceptible influence of Caravaggio is subordinated to tonal values of black, grey and shades of brown, a typical feature of the mature work of Velázquez. Purchased in Madrid by Elector Wilhelm of the Palatinate in 1694 for the Düsseldorf gallery.

145

**Juan Pantoja de la Cruz**
Valladolid 1553–Madrid 1608
*The Infanta Clara Eugenia of Spain*
signed and dated 1599
Canvas
125 x 97 cm [898]

Companion piece to the portrait of Albrecht the Pious, Archduke of Austria, both were marriage portraits in accordance with the strict etiquette of the 'Spanish fashion'. Acquired in 1804 when the Benedictine monastery of Howenwart was secularized.

146

**El Greco**
**(Doménikos Theotokópulos)**
Candia, Crete, 1541–Toledo 1614
*The Disrobing of Christ*
c. 1590/1600
Canvas
165 x 99 cm [8573]

The painting, treating the theme in a powerfully spiritual way, follows the description in the apocryphal gospel of Nicodemus. This was the third independent version of the theme: El Greco made the first for the sacristy of the cathedral in Toledo. Purchased from French art dealers in 1909 (Tschudi Donation).

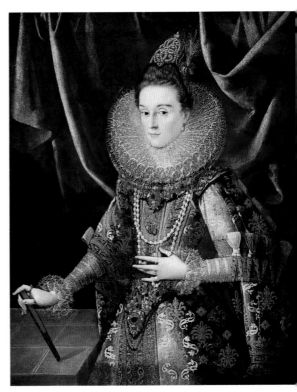

145

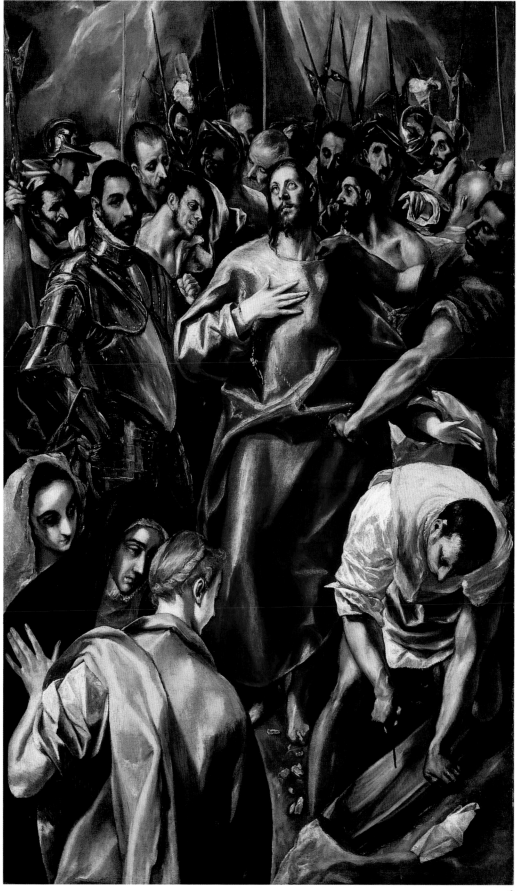

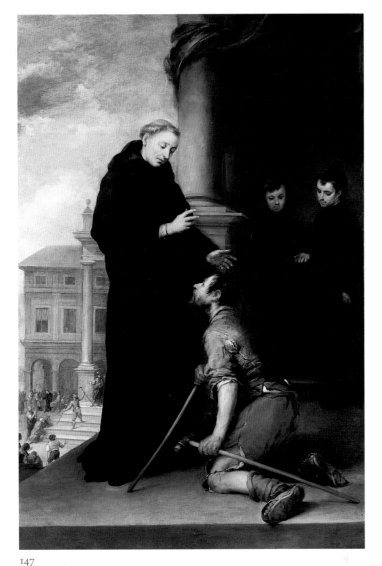

147

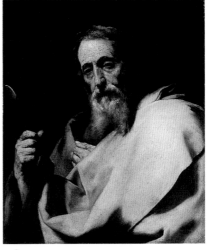

148

149

**147**
**Bartolomé Esteban Murillo**
Seville 1618–Seville 1682
*St Thomas of Villanueva Healing
a Lame Man*
c. 1670/80
Canvas
221 x 149 cm [52]

The Augustine hermit, active
in the 16th century, was greatly
revered in Spain as a friend of
the poor and the sick. Painted
for the monastery church of St
Augustine in Seville along with
its companion piece *St Thomas
as a Child Distributing His Clothes*
(Cincinnati Museum). Purchased
in 1815 by King Max I from
General Sebastiani in Paris.

**148**
**José de Ribera**
Játiva (Valencia) 1591–Naples
1652
*St Bartholomew*
c. 1633/35
Canvas
76 x 64 cm [7604]

In spite of the crude *verismo* in
the style of his model Caravaggio,
Ribera's saints have a highly
ascetic and spiritual look.
Purchased by King Max II in
1861 from the estate of the
gallery curator Gündter in
Munich.

**149**
**Francisco Zurbarán y Salazar**
Fuente de Cantos (Estremadura)
1598–Madrid 1664
*St Francis in Ecstasy*
c. 1660
Canvas
65 x 53 cm [504]

This rendering of the saint,
with his Capuchin habit and in
mystical ecstasy, follows a
scheme prevailing since the
Council of Trent. In his late
works, Zurbarán's austere style
of paintings shows a softening
under the influence of Murillo's
more genial palette. From the
Mannheim gallery.

**150**
**Francisco Zurbarán y Salazar**
Fuente de Cantos (Estremadura)
1598–Madrid 1664
*The Entombment of St Catherine
of Alexandria on Mount Sinai*
c. 1637
Canvas
201.5 x 126 cm [14933]

This altarpiece, painted for the
Chapel of St Catherine in the
church of San José in Seville,
was in France from the time of
the Napoleonic War until 1810.
It comes from Zurbarán's period
of greatest creativity, of which
the 'mystical style' is most
characteristic, uniting the
everyday and earthly with the
heavenly in sublime fashion.

151

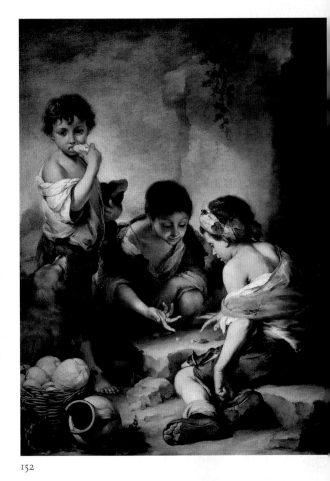

152

151
**Bartolomé Esteban Murillo**
Seville 1618–Seville 1682
*The Grape and Melon Eaters*
c. 1645/46
Canvas
146 x 104 cm [605]

Like Caravaggio before him in
Italy, Murillo began by exploring
the *vida picaresca* of the vagabond
rascals of Seville. With five
paintings, Munich has the finest
collection of such genre pictures,
which Murillo only painted
occasionally and which had
already become rare in the 18th
century. Probably purchased by
Elector Max Emanuel in 1698
during his period as governor in
the Netherlands.

152
**Bartolomé Esteban Murillo**
Seville 1618–Seville 1682
*Boys Playing Dice*
c. 1670/75
Canvas
146 x 108 cm [597]

Acquired in 1698 by Elector Max
Emanuel of Bavaria from the
collection of the merchant Gisbert
van Colen. It is regarded as one
of the artist's best genre-paintings,
offering a consummate example
of his late Baroque style.

153
**Bartolomé Esteban Murillo**, detail
of *The Grape and Melon Eaters*
(plate 151)

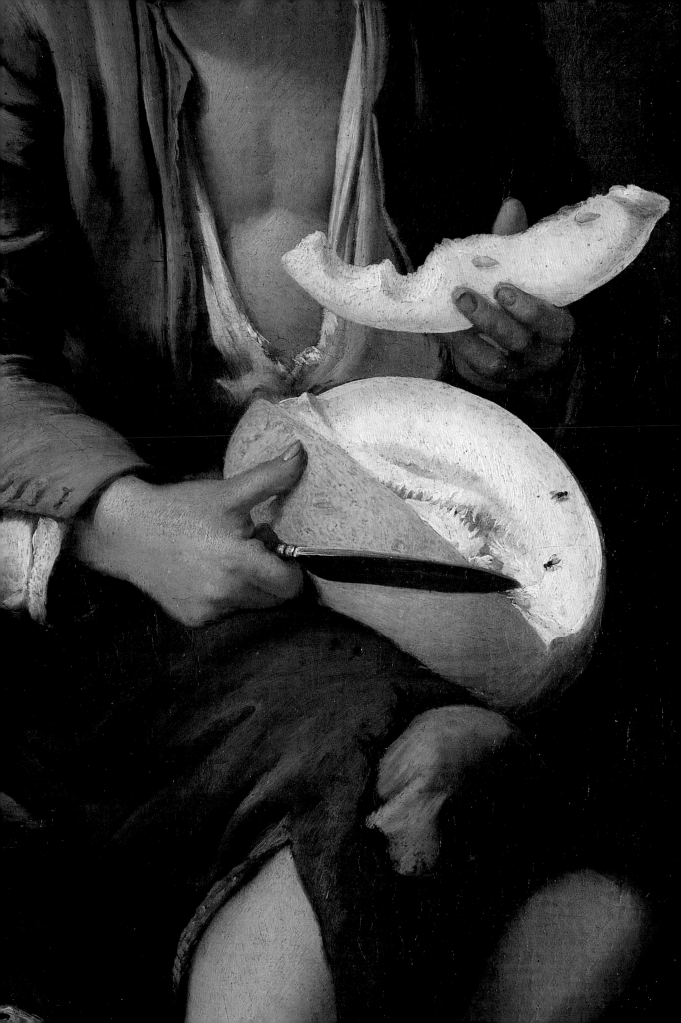

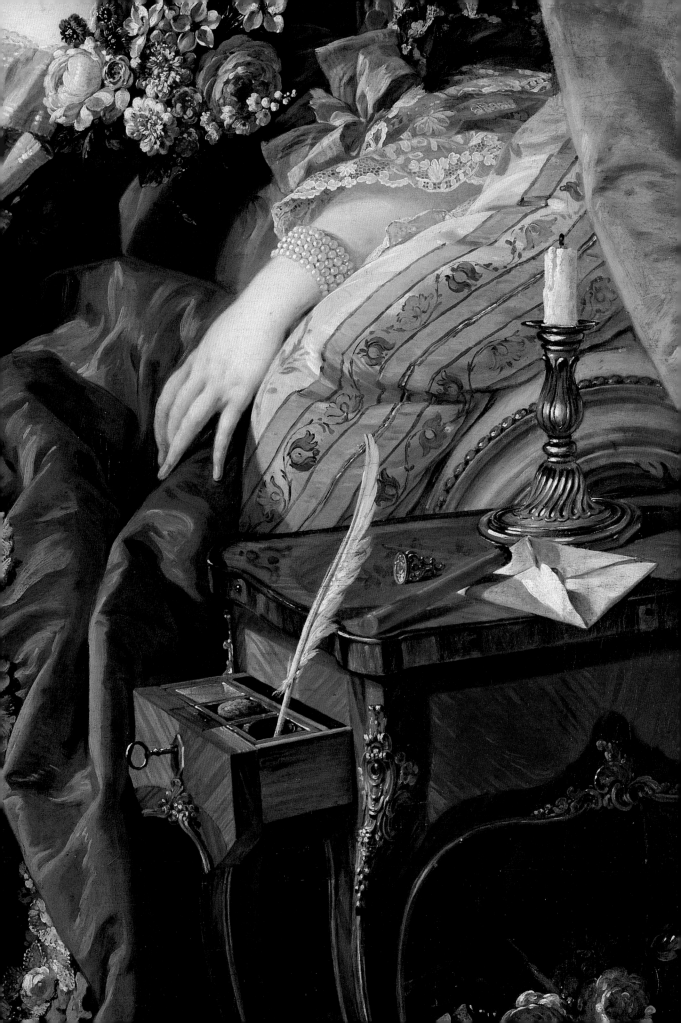

# French Painting

The collecting zeal of the various lines of the Wittelsbach dynasty, with its main concentration on early German, Netherlandish and Italian painting, led to the Alte Pinakothek becoming one of the most important galleries in the world. Strangely enough, none of the Bavarian nor the Palatinate electors collected French paintings to any great extent, in spite of the ties of blood and also the political links they had with France. Thus the French section has remained the smallest after the Spanish in the Bavarian State Painting collections. About one-tenth of the whole collection of some 400 pictures is on display in the Alte Pinakothek.

The Wittelsbachs residing in Munich only occasionally purchased works by French masters. For example, in the reign of Elector Ferdinand Maria (reigned 1636–79) two paintings by Claude Lorrain joined the collection, namely *Seaport with Rising Sun* (plate 158) and *Idyllic Landscape at Sunset*, both of which had been in the possession of the imperial counsellor Baron Franz von Mayer of Regensburg. *The Roman Lime-kiln* by Sebastian Bourdon, which was probably purchased later, also came from the Von Mayer collection. Three other pictures by Poussin are not recorded in the inventories until the middle of the eighteenth century — the *Lamentation* (plate 155), *Midas and Bacchus* (plate 156) and *Apollo and Daphne*. Mention is made of Bourdon's *Perseus and Andromeda* in the Badenburg in Nymphenburg as early as 1751, and of *The Small Christ Crowned with Thorns* and *Erminia among the Shepherds* by Valentin de Boulogne around the same time in the Munich Residenz. Between 1706 and 1712, and again from 1716 onwards, Joseph Vivien was employed as court painter to Elector Max Emanuel. He was the source of a series of important paintings which, except for the portrait of Archbishop Fénelon, were exhibited in the State gallery in Schleissheim Palace. In spite of very close ties with France, Max Emanuel did not purchase any notable paintings of the French school. On the other hand, his expensive acquisitions of Flemish and Dutch masters made Schleissheim one of the most significant galleries in Europe.

The Zweibrücken collection was the latest Wittelsbach gallery to be brought to Munich, in 1799. As part of the old collections had been auctioned in Paris in 1778, Duke Karl August (1746–95), whose reign had begun in the same year, felt obliged to lay in new ones. First he purchased the collection of his court painter, Christian von Mannlich, who later became director of the Munich gallery, then that of the Palatine court architect, Nicolas de Pigage. In barely twenty years the collection had grown to 2,000 pictures, for which special rooms had to be built in Carlsberg Castle. From Mannlich's collection came the two famous pictures by Claude Lorrain, *The Repudiation of Hagar* (plate 159) and *Hagar and Ismael in the Wilderness*. Some notable eighteenth-century French paintings also came to Munich for the first time via the Zweibrücken gallery, among them Boucher's *Girl Resting* (plate 168),

Chardin's *Woman Scraping Vegetables* (plate 163), the portrait of the Count Palatine Michael von Zweibrücken-Birkenfeld by Louis Tocqué, works by Le Moine and Charles-Antoine Coypel, and nine paintings by Joseph Vernet.

From 1966 onwards General Director Halldor Soehner began to build up a collection of eighteenth-century French and Venetian painting for the Bayerische Hypotheken- und Wechselbank, which were to be hung in the Alte Pinakothek on permanent loan. In this way the Bank stepped into the role of patron, vacated by the Wittelsbach collectors, enriching the Alte Pinakothek with a new dimension. Works by masters who had previously either not been represented at all or only inadequately were now added to the French section. For example: *The Birdcage* by Nicolas Lancret (plate 160), *The Joys of Country Life* by Jean Baptiste Pater (plate 161), the *Pastoral Landscape* by François Boucher, the two pastel portraits of the Abbé Nollet and of Mademoiselle Ferrand by Maurice Quentin de la Tour (plate 166).

Since 1969 the Bayrische Hypotheken- und Wechselbank has continued its activities, with Erich Steingräber as its adviser. To crown its acquisitions, in 1971 it purchased one of the major works of Jean Marc Nattier, *The Marquise de Baglion as Flora* (plate 164); the famous full-length portrait of the Marquise de Pompadour by François Boucher  (plate 167); and the only important painting by Jacques Louis David to be held by a German gallery, the portrait of *The Marquise de Sorcy de Thélusson*, now in the Neue Pinakothek. Two large-scale pastoral landscapes from François Boucher's early period have been placed at the gallery's disposal as a loan by the Bayrische Landesbank.

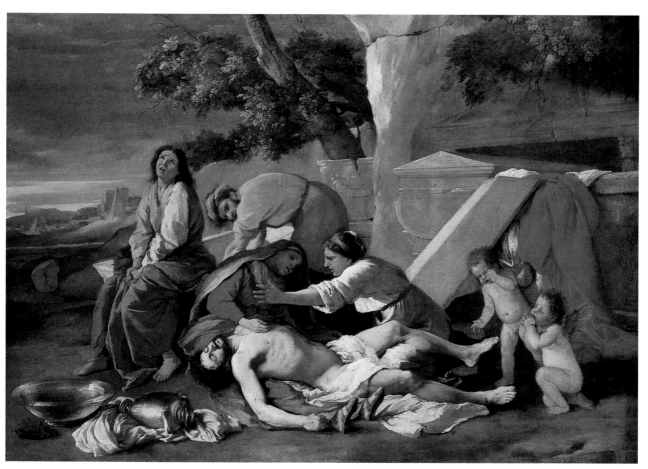

155

155
**Nicolas Poussin**
Villiers, near Les Andelys
(Normandy) 1594–Rome 1655
*Lamentation*
*c.* 1626/30
Canvas
103 x 146 cm  [625]

A strictly architecturally
constructed composition with
bold colouring, oriented towards
Italian models of the 16th
century (Raphael, Titian,
Annibale Carracci). From the
Elector's gallery in Munich.

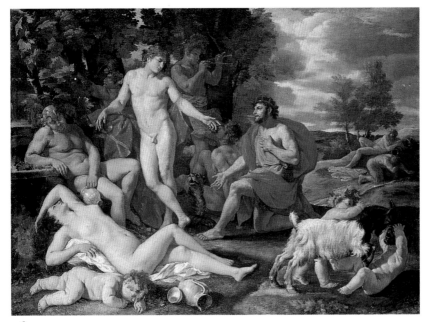

156

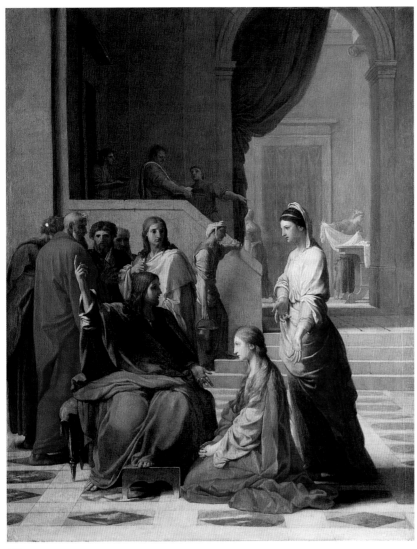

157

156
**Nicolas Poussin**
Villiers, near Les Andelys
(Normandy) 1594–Rome 1655
*Midas and Bacchus*
probably before 1627
Canvas
98 x 153 cm  [528]

A scene from Ovid's
*Metamorphoses* (XI, 85-145).
The connection with Titian's
Bacchanals is unmistakable.
From the Elector's gallery in
Munich.

157
**Eustache le Sueur**
Paris 1617–Paris 1655
*Christ at the House of Martha*
c. 1645/50
Canvas
162 x 130 cm  [WAF 492]

Christ, accompanied by his
disciples, visits the sisters Mary
and Martha (Luke 10:40). The
solemn, classically graceful
composition is clearly inspired
by Italian High Renaissance
models. Purchased by King
Ludwig I from the owner, Cardinal
Fesch, in Paris in 1845.

159
**Claude Lorrain (Claude Gellée)**
Chamagne (Lorraine) 1660–
Rome 1682
*The Repudiation of Hagar*
signed and dated 1668
Canvas
106 x 140 cm  [604]

At the instigation of Abraham's
wife Sarah, Hagar is banished
from the house with her son
Ismael (Genesis 21:10-14). In this
late work, an inner intensity and
tranquillity have taken the place
of the solemn monumentality of
Claude's early period.
Commissioned by Count Johann
Friedrich von Waldstein (along
with the companion piece,
*Ismael in the Desert*, also in the
Alte Pinakothek). From the
Zweibrücken gallery.

158
**Claude Lorrain (Claude Gellée)**
Chamagne (Lorraine) 1600–
Rome 1682
*Seaport with Rising Sun*
signed and dated 1674
Canvas
72 x 96 cm [381]

The latest of three versions.
The impression is one of solemn
order, for which the coinciding
of the painting's rectangular lines
with the radial beams of the
morning sun, shown almost in
the centre of the picture, is
essential. Claude is reverting
here to compositional methods
of his early period. From the
Elector's gallery in Munich.

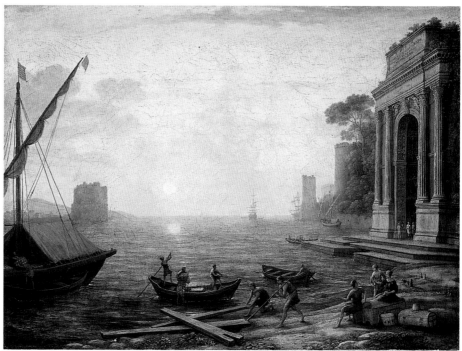

158

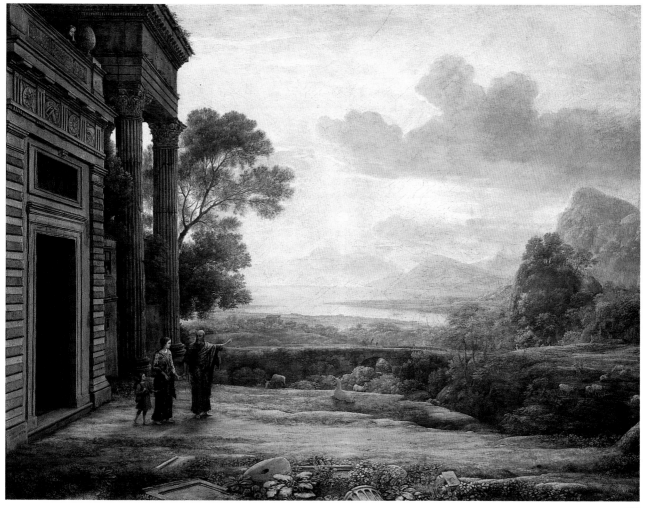

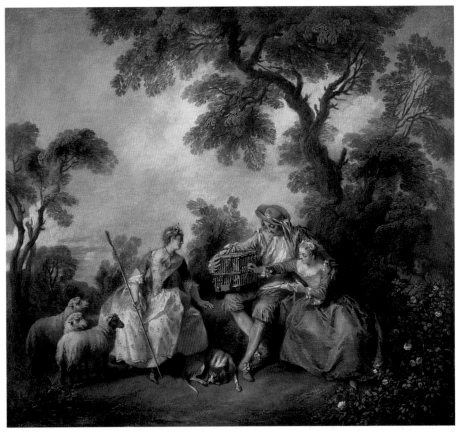

160

161

160

**Nicolas Lancret**
Paris 1690–Paris 1745
*The Birdcage*
c. 1735
Canvas
44 x 48 cm [HUW 4]

The Arcadian shepherd's paradise, rediscovered by the Renaissance, lives on in French rococo painting as a 'staged' pastoral idyll, a veiled dream of Eden, especially in the works of Watteau, Lancret and Pater. Formerly in the collection of Frederick the Great in Potsdam. Purchased for the collection of the Bayrische Hypotheken- und Wechselbank in the Alte Pinakothek in 1966.

161

**Jean Baptiste Joseph Pater**
Valenciennes 1695–Paris 1736
*The Joys of Country Life*
c. 1735
Canvas
54 x 66 cm [HUW 7]

Here the yearning of the frivolous urban society of Louis Quinze for a lost paradise is depicted, rather than simple peasant life in the country. The lovers and ladies dressed according to Watteau fashions point to Pater's great teacher. Purchased from Baron Alfred de Rothschild's collection in 1966 for that of the Bayrische Hypotheken- und Wechselbank in the Alte Pinakothek.

162

**162**
**François Boucher**
Paris 1703–Paris 1770
*Rest by the Fountain*
signed *c.* 1730/35
Canvas
239 x 232 cm  [BGM 3]

Companion piece to the *Country Idyll*, also in the Alte Pinakothek, this pastoral landscape uses impressions of Boucher's three-year stay in Italy (1727–30). Probably painted for the Conde de Contamina in Madrid (originally with the addition of segmental arch). Purchased in 1976 for the Batrische Landesbank collection in the Alte Pinakothek.

**163**
**Jean Baptiste Chardin**
Paris 1699–Paris 1779
*Woman Scraping Vegetables*
signed *c.* 1748
Canvas
46 x 37 cm  [1090]

Chardin's genre paintings enjoyed great popularity — hence the four versions of this composition, the earliest of which is dated 1738 (Washington DC, National Gallery). From the Zweibrücken gallery.

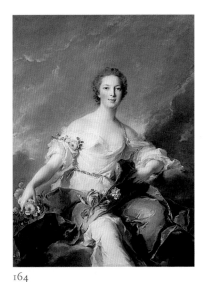

164

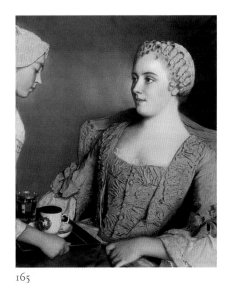

165

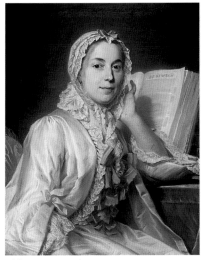

166

**164**
**Jean Marc Nattier**
Paris 1685–Paris 1766
*The Marquise of Baglion
as Flora*
signed and dated 1746
Canvas
137 x 106 cm  [HUW 19]

Angélique Louise-Sophie
d'Allouville de Louville,
Marquise de Baglion (1719–56),
was considered to be one of the
most beautiful women of her
time. Purchased from New York
art dealers in 1971 for the
Bayrische Hypotheken- und
Wechselbank collection in the
Alte Pinakothek.

**165**
**Jean-Etienne Liotard**
Geneva 1702–Geneva 1789
*The Early Breakfast*
1753/56
Pastel on parchment
61 x 51 cm  [HUW 30]

Painted during his stay in
London between 1753 and
1756 and given an English title.
The bold infringement of the
frame by the maidservant at
the left side anticipates artistic
methods which were not used
until the advent of Japonism in
the 19th century (by Degas,
among others). Purchased in
1974 for the collection of the
Bayrische Hypotheken- und
Wechselbank in the Alte
Pinakothek.

**166**
**Maurice Quentin de la Tour**
St Quentin (Aisne) 1704–St
Quentin 1788
*Mademoiselle Ferrand
Meditating on Newton*
1752/53
Pastel
73 x 60 cm  [HUW 6]

Displayed in the Salon in 1753.
The sitter, about whom nothing
else is known, has a lively
presence and is portrayed in a
dressing-gown. The works
of the physicist Newton were the
subject of much discussion in the
salons of the time. Purchased in
1966 for the collection of the
Bayrische Hypotheken- und
Wechselbank in the Alte
Pinakothek.

**167**
**François Boucher**
Paris 1703–Paris 1770
*Portrait of the Marquise de
Pompadour*
signed and dated 1756
Canvas
201 x 157 cm  [HUW 18]

Jeanne-Antoinette Poisson
(1721–64) became Louis XV's
mistress in 1745 and was given
the title of Madame de Pompadour.
This sumptuous portrait depicts
not only the beauty of the most
influential personality at the
court of Versailles but alludes to
her particular abilities and
intellectual and artistic interests.
Purchased from art dealers in
New York in 1971 for the
collection of the Bayrische
Hypotheken- und Wechselbank
in the Alte Pinakothek.

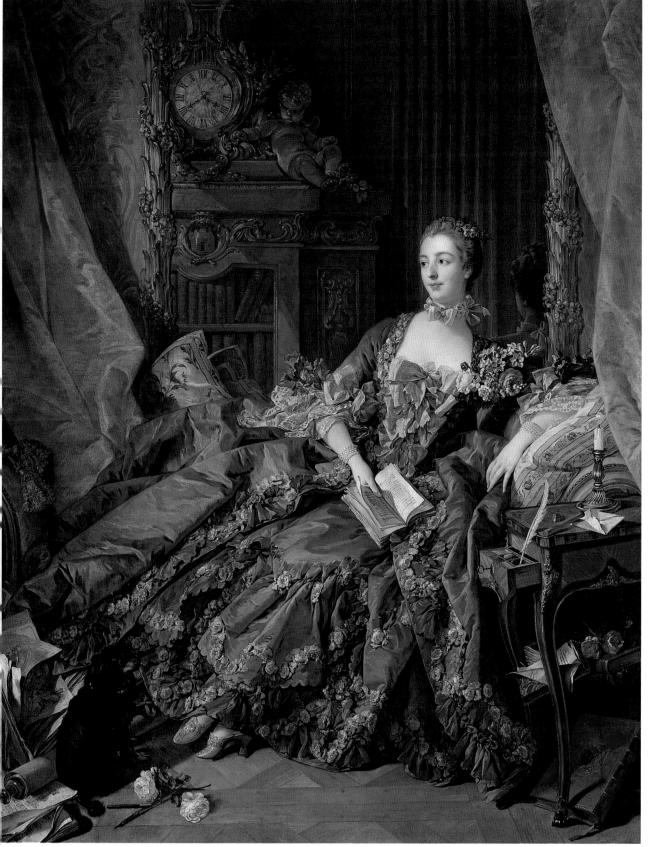

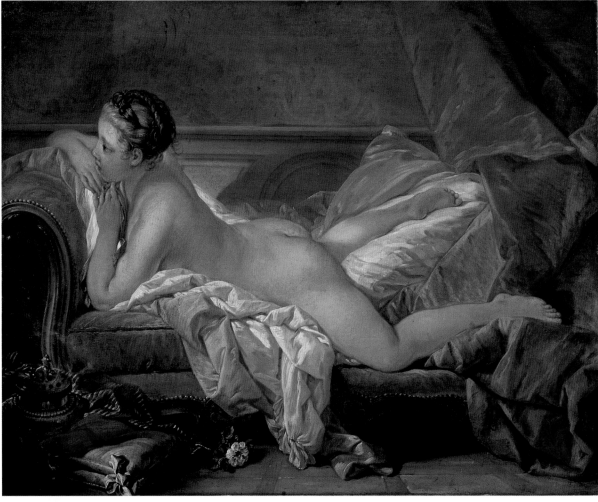

168

169

168
**François Boucher**
Paris 1703–Paris 1770
*Girl Resting (Portrait of Louise O'Murphy)*
signed and dated 1752
Canvas
59 x 73 cm [1166]

The subject, born in Rouen in 1737, was the painter's model for some time, and became King Louis XV's mistress in 1753. From the Zweibrücken gallery.

169
**Jean Honoré Fragonard**
Grasse 1732–Paris 1806
*Girl with Dog*
c. 1770
Canvas
89 x 70 cm [HUW 35]

The levity of the subject, signifying the loose morals of rococo society, is most beautifully sublimated by the virtuoso, sketch-like painting. Nevertheless, the picture obviously had a shocking effect for neither it nor the engraving made from it was ever exhibited to the general public. Purchased from a private owner in Paris in 1977 for the collection of the Bayrische Hypotheken- und Wechselbank in the Alte Pinakothek.

170

171

170
**Hubert Robert**
Paris 1733–Paris 1808
*The Demolition of Houses on
the Pont au Change*
1788
Canvas
80 x 155 cm [HUW 15]

The houses on the bridge were
pulled down in 1788 at the order
of King Louis XVI for hygenic
reasons. Robert painted a
number of such highly popular
'journalistic' pictures. Purchased
from a private owner in Paris in
1968 for the collection of the
Bayrische Hypotheken- und
Wechselbank in the Alte
Pinakothek.

171
**Joseph Vernet**
Avignon 1714–Paris 1789
*Oriental Seaport at Sunrise*
1755, signed
Copper
30 x 43 cm [2348]

Commissioned from the painter,
along with its companion piece
*Fishing on the River in the Evening*
(also in the Alte Pinakothek), by
Pierre Charles de Villette in 1751.
The effect of this painting rests,
as in the work of Claude Lorrain,
on the significance of light. From
the Zweibrücken gallery.

# Bibliography

*Katalog der Gemälde-Sammlung der kgl. älteren Pinakothek in München*, Munich 1884.

*Ältere Pinakothek München, Amtlicher Katalog*, Munich 1936.

## COLLECTION CATALOGUES

Vol. I *Spanische Meister*, Halldor Soehner, ed., Munich 1964.

Vol. IX *Venezianische Gemälde des 15. und 16. Jahrhunderts*, Rolf Kultzen and Peter Eikemeier, eds., Munich 1971.

Bd. XIV *Altdeutsche Gemälde. Köln und Nordwestdeutschland*, Gisela Goldberg and Gisela Scheffler, eds., Munich 1972.

## CATALOGUES

*Alte Pinakothek Band I, Deutsche and niederländische Malerei zwischen Renaissance und Barock*, Ernst Brochhagen and Kurt Löcher, eds., 3rd edition, Munich 1973.

*Alte Pinakothek Band II, Altdeutsche Malerei*, Christian Altgraf Salm and Gisela Goldberg, eds., Munich 1963.

*Alte Pinakothek Band III, Holländische Malerei*, Ernst Brochhagen and Brigitte Knüttel, eds., Munich 1967.

*Alte Pinakothek Band IV, Französische und spanische Malerei*, Halldor Soehner and Johann Georg Prinz von Hohenzollern, eds., Munich 1972.

*Alte Pinakothek Band V, Italienische Malerei*, Rolf Kultzen, ed., Munich 1975.

## INTRODUCTIONS

*Alte Pinakothek München. Erläuterungen zu den ausgestellten Werken*, 3rd edition, Munich 1999.

Rüdiger van der Heiden, *Die Alte Pinakothek. Sammlungsgeschichte, Bau und Bilder*, Munich 1998.

# Index

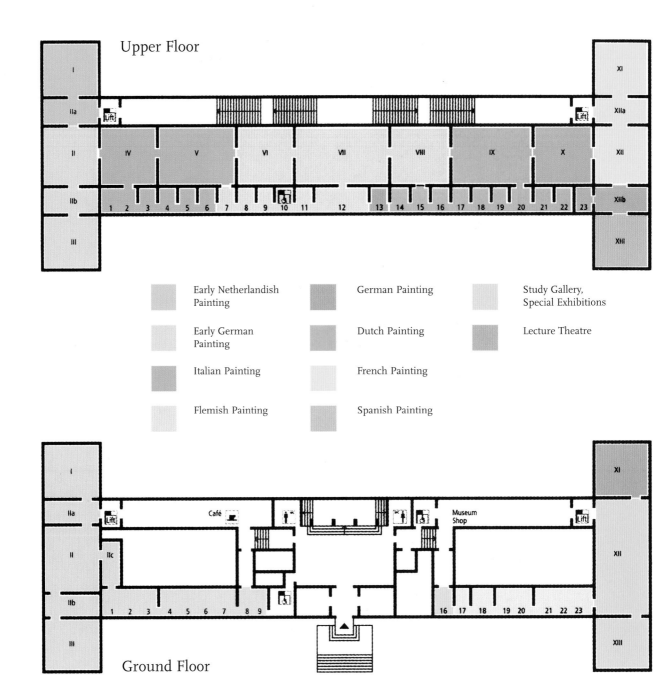

**Upper Floor**

**Ground Floor**

Early Netherlandish Painting

Early German Painting

Italian Painting

Flemish Painting

German Painting

Dutch Painting

French Painting

Spanish Painting

Study Gallery, Special Exhibitions

Lecture Theatre